mixed media workshop

Isaac Anderson, Joe Martino,

Bette McIntire, Mark Mendez,

Suzette Rosenthal & Patricia Swartout

Walter Foster Publishing, Inc.
3 Wrigley, Suite A
Irvine, CA 92618
www.walterfoster.com

Managing Editor: Rebecca J. Razo
Art Director: Shelley Baugh
Assistant Project Manager: Emily Green
Senior Editor: John Welches
Associate Editor: Stephanie Meissner
Production Designers: Debbie Aiken, Amanda Tannen
Production Manager: Nicole Szawlowski
Production Coordinator: Lawrence Marquez
Administrative Assistant: Kate Davidson

Table of Contents

Tools & Materials

Each of the artists featured in this book incorporates his or her own unique set of mixed-media tools and materials; however, this chapter covers traditional tools and materials you'll need to complete the projects in this book, as well as some basic techniques that will help you achieve special effects. All other materials are listed at the start of each project. The degree to which you re-create the projects is up to you. It is recommended that you read all of the project steps before beginning. You can often substitute hard-to-find objects and paper products for materials that you have readily available.

Drawing Supplies

▶ **Paper** Drawing paper is available in a range of surface textures: smooth grain (plate finish and hot pressed), medium grain (cold pressed), and rough to very rough. Rough paper is ideal when using charcoal; smooth paper is best for watercolor washes. The heavier the paper, the thicker its weight. Thick paper is better for graphite drawing because it can withstand erasing better than thin paper.

◀ **Drawing Pencils** Artist's pencils contain a graphite center and are sorted by hardness (or grade) from very soft (9B) to very hard (9H). A good starter set includes a 6B, 4B, 2B, HB, B, 2H, 4H, and 6H.

◀ **Colored Pencils** There are three types of colored pencils: wax based, oil based, and water soluble. Oil-based pencils complement wax pencils nicely. Water-soluble pencils have a gum binder that reacts to water in a manner similar to watercolor.

◀ **Art Pens** There are a number of ink, gel, indelible, and poster-paint art pens on the market that are useful for rendering fine details in your mixed-media projects. Experiment with a variety of pens to see which ones you like best for your particular projects.

▶ **Erasers** There are several types of art erasers. Plastic erasers are useful for removing hard pencil marks and large areas. Kneaded erasers can be molded into different shapes and used to dab an area, gently lifting tone from the paper.

► **Watercolors** Watercolors come in pans or tubes. Tubes contain moist, squeezable paint and are useful for creating large quantities of color. Artist-quality watercolors are made with a higher ratio of natural pigments to binders, so they are generally brighter in appearance. Student-quality watercolors use more synthetic pigments or mixes of several types of pigments.

◄ **Pastels** Pastels come in oil pastels; hard, clay-based pastels; and soft pastels, which are chalklike sticks. Soft pastels produce a beautiful, velvety texture and are easy to blend with your fingers or a soft cloth. Pastels are mixed on the paper as you paint; therefore, it's helpful to have a range of colors in various "values"—lights, mediums, and darks—readily available.

► **Acrylics** Acrylic paints come in jars, cans, and tubes. Most artists prefer tubes, as they make it easy to squeeze out the appropriate amount of paint onto your palette. Acrylic is a fun medium. It dries much faster than oil, making it easier to paint over mistakes, although it's less forgiving when blending. As with other types of paint, acrylics come in artist and student grade. Artist-grade paints contain more pigment and produce truer colors than student-grade paints, which contain more filler. Most mixed-media artists work with acrylic paints. In addition, there are a number of acrylic mediums, including glazing, thickening, dispersing, and texturing mediums, that can help you achieve a range of effects.

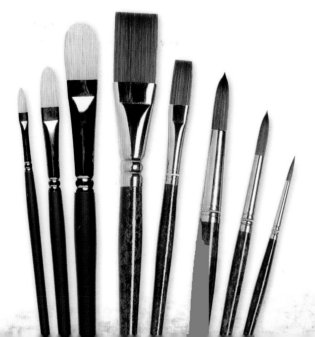

◄ **Brushes** The three basic brush styles are flats, rounds, and filberts. Large and medium flats are good for painting washes and filling in large areas. Smaller flats are essential for detail work; drybrushing; and making clean, sharp edges. Larger rounds and filberts are useful for sketching outlines and general painting, whereas the smaller sizes are essential for adding intricate details. Brushes are grouped by hair type (soft or stiff and natural or synthetic), style, and size. Always wash your brushes after using them; then reshape the bristles and lay them flat or hang them to dry. Never store brushes bristle-side down.

Other Art Essentials Other tools you may want to have on hand include a ruler, artist tape, art markers and crayons, blending stumps, a pencil sharpener, and a utility knife for cutting drawing boards.

Drawing Techniques

Drawing consists of three elements: line, shape, and form. The shape of an object can be described with a simple one-dimensional line. The three-dimensional version of the shape is known as the object's "form." In pencil drawing, variations in value (the relative lightness or darkness of black or a color) describe form, giving an object the illusion of depth. In pencil drawing, values range from black (the darkest value) through different shades of gray to white (the lightest value). To make a two-dimensional object appear three-dimensional, you must pay attention to the values of the highlights and shadows. When shading a subject, consider the light source, as this is what determines where highlights and shadows will be.

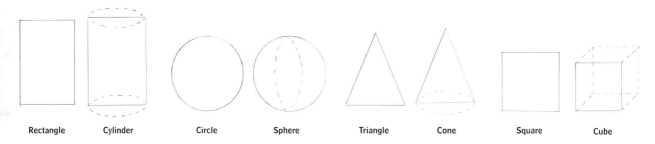

| Rectangle | Cylinder | Circle | Sphere | Triangle | Cone | Square | Cube |

Moving from Shape to Form The first step in creating an object is establishing a line drawing or outline to delineate the flat area that the object takes up. This is known as the "shape" of the object. The four basic shapes—the rectangle, circle, triangle, and square—can appear to be three-dimensional by adding a few carefully placed lines that suggest additional planes. By adding ellipses to the rectangle, circle, and triangle, you've given the shapes dimension and have begun to produce a form within space. Now the shapes are a cylinder, sphere, and cone. Add a second square above and to the side of the first square, connect them with parallel lines, and you have a cube.

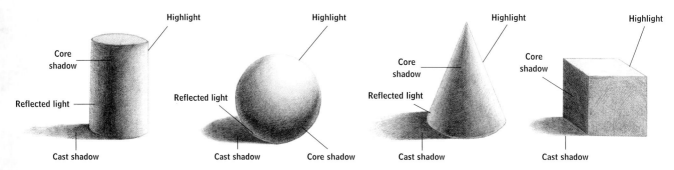

Adding Value to Create Form A shape can be further defined by showing how light hits the object to create highlights and shadows. Note from which direction the source of light is coming; then add the shadows accordingly. The core shadow is the darkest area on the object and is opposite the light source. The cast shadow is what is thrown onto a nearby surface by the object. The highlight is the lightest area on the object, where the reflection of light is strongest. Reflected light is the surrounding light reflected into the shadowed area of an object.

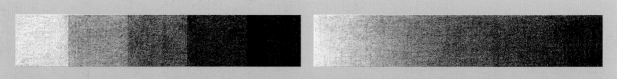

Creating Value Scales Just as a musician uses a musical scale to measure a range of notes, an artist uses a value scale to measure changes in value. You can refer to the value scale so you'll always know how dark to make your dark values and how light to make your highlights. The scale also serves as a guide for transitioning from lighter to darker shades. Making your own value scale will help familiarize you with the different variations in value. Work from light to dark, adding more and more tone for successively darker values (as shown above left). Then create a blended value scale (as shown above right). Use a tortillon to smudge and blend each value into its neighboring value from light to dark to create a gradation.

Practicing Lines

When drawing lines, it is not necessary to always use a sharp point. In fact, sometimes a blunt point may create a more desirable effect. When using larger lead diameters, the effect of a blunt point is even more evident. Experiment with your pencils to familiarize yourself with the different types of lines they can create.

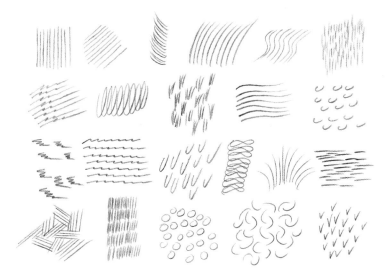

Drawing with a Sharp Point The lines at left were drawn with a sharp point. Draw parallel, curved, wavy, and spiral lines; then practice varying the weight of the lines as you draw. Os, Vs, and Us are some of the most common alphabet shapes used in drawing.

Drawing with a Blunt Point The shapes at right were drawn using a blunt point. Note how the blunt point produced different images. You can create a blunt point by rubbing the tip of the pencil on a sandpaper block or on a rough piece of paper.

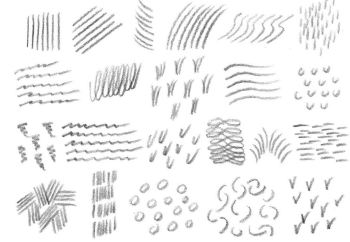

"Painting" with Pencil

When you use painterly strokes, your drawing will take on a new dimension. Think of your pencil as a brush, and allow yourself to put more of your arm into the stroke. The larger the lead, the wider the stroke; the softer the lead, the more painterly the effect. The examples shown here were drawn on smooth paper with a 6B pencil, but you can experiment with rough paper for more broken effects.

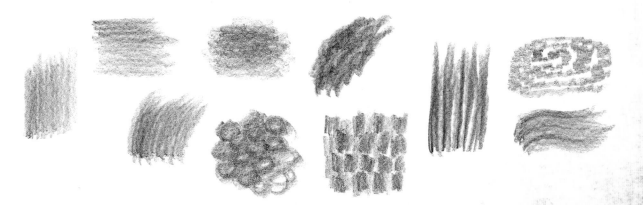

Painting Techniques

There are myriad techniques and tools for creating a variety of textures and effects. By employing some of these different techniques, you can spice up your art and keep the process fresh, exciting, and fun!

Oil & Acrylic Techniques

Flat Wash This thin mixture of acrylic paint has been diluted with water. (Use solvents to dilute oil paint.) Lightly sweep overlapping, horizontal strokes across the support.

Drybrush Use a worn, flat or fan brush loaded with thick paint, wipe it on a paper towel to remove moisture, and then apply it to the surface using quick, light, irregular strokes.

Impasto Use a paintbrush or a painting knife to apply thick, varied strokes, creating ridges of paint. This technique can be used to punctuate highlights in a painting.

Scumble With a dry brush, lightly scrub semi-opaque color over dry paint, allowing the underlying colors to show through. This is excellent for conveying depth.

Glaze Apply thin, diluted layers of transparent color over existing dry color. Let the paint dry between each layer.

Lifting Out Use a moistened brush or a tissue to press down on a support and lift colors out of a wet wash. If the wash is dry, wet the desired area, and lift out with a paper towel.

Watercolor & Gouache Techniques

Wet on Dry This method involves applying different washes of color on dry watercolor paper and allowing the colors to intermingle, creating interesting edges and blends.

Variegated Wash A variegated wash differs from the wet-on-dry technique in that wet washes of color are applied to wet paper instead of dry paper. The results are similar, but using wet paper creates a smoother blend of color. Using clear water, stroke over the area you want to paint and let it begin to dry. When it is just damp, add washes of color and watch them mix, tilting your paper slightly to encourage the process.

Wet into Wet Begin by generously stroking clear water over the area you want to paint, and wait for it to soak in. When the surface takes on a matte sheen, apply another layer of water. When the paper again takes on a matte sheen, apply washes of color, and watch the colors spread and softly blend.

Glazing Glazing is a traditional watercolor technique that involves two or more washes of color applied in layers to create a luminous, atmospheric effect. Glazing unifies the painting by providing an overall underpainting (or background wash) of consistent color.

Charging In Color This technique involves adding pure, intense color to a more diluted wash that has just been applied. The moisture in the wash will "grab" the new color and pull it in, creating irregular edges and shapes of blended color.

Color Theory

Knowing a little about basic color theory can help when working with mixed media. The primary colors (red, yellow, and blue) are the three basic colors that cannot be created by mixing other colors; all other colors are derived from these three. Secondary colors (orange, green, and purple) are a combination of two primaries. Tertiary colors (red-orange, red-violet, yellow-orange, yellow-green, blue-green, and blue-violet) are a combination of a primary color and an adjacent secondary color.

The Color Wheel

A color wheel is a visual representation of colors arranged according to their chromatic relationship. The basic color wheel consists of 12 colors that can be broken down into three different groups: primary colors, secondary colors, and tertiary colors.

Color Schemes

Choosing and applying a color scheme (or a selection of related colors) can help you achieve unity, harmony, or dynamic contrasts. Explore these different schemes to understand color relationships and to practice mixing colors.

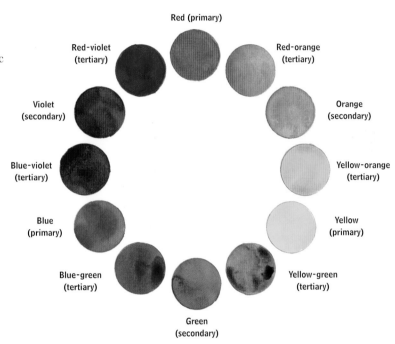

Red (primary)
Red-violet (tertiary)
Red-orange (tertiary)
Violet (secondary)
Orange (secondary)
Blue-violet (tertiary)
Yellow-orange (tertiary)
Blue (primary)
Yellow (primary)
Blue-green (tertiary)
Yellow-green (tertiary)
Green (secondary)

Complementary Complementary colors are colors that are opposite each other on the color wheel. Red and green, orange and blue, and yellow and purple are examples of complementary colors. When placed adjacent to each other, complements make each other appear brighter. When mixed, they have the opposite effect, neutralizing (or graying) each other.

Split-Complementary This scheme includes a main color and a color on each side of its complementary color. An example of this would be red, yellow-green, and blue-green.

Triadic This scheme consists of three colors that form an equilateral triangle on the color wheel. An example of this would be blue-violet, red-orange, and yellow-green.

Analogous Analogous colors are adjacent to each other on the color wheel. Analogous color schemes are good for creating unity within a painting. You can do a tight analogous scheme (a small range of colors) or a loose analogous scheme (a larger range of related colors). Examples of tight analogous color schemes would be red, red-orange, and orange; or blue-violet, blue, and blue-green. A loose analogous scheme would be blue, violet, and red.

Tetradic Four colors that form a square or a rectangle on the color wheel create a tetradic color scheme. This color scheme includes two pairs of complementary colors, such as orange and blue and yellow-orange and blue-violet. This is also known as a "double-complementary" color scheme.

Altered Photos
with Isaac Anderson

As a boy, Isaac Anderson enjoyed perusing art galleries in his hometown of Seattle, Washington, critiquing the exhibitions and desiring to one day see his own work displayed on the gallery walls. He had a passion for the arts, and as the son of a talented glass blower and a very creative mother with darkroom equipment, the sky was the limit.

Isaac later attended college abroad. Armed with his grandfather's antique 35mm camera and its original owner's manual, Isaac's appreciation for photography was birthed. This passion developed and broadened into documentary filmmaking, which opened the doors for travel to some unique places. Isaac filmed and experienced the stories of the characters he met in his travels—stories that shook him to his core.

Isaac received a BA in communications in 2000 after studying in the Pacific Northwest, Chicago, and England. Since then, he has spent several years in Southern California refining and challenging his artistic technique in mixed-media painting, photography, and documentary filmmaking. A self-taught artist, Isaac continues to experiment with new materials and approaches to his fresco-secco, mixed-media works. Visit isaacandersonart.com.

Inside the Artist's Studio

I am a storyteller. When I approach a project, I contemplate the story I want to convey, determining the emotion and response I wish to elicit from viewers. I want my work to start conversations, allowing onlookers to move through the process with me. Art has the power to steer people toward truth or toward a forged reality. When creating, it is my desire to illustrate truth and point people toward redemptive engagement.

As I create mixed-media art, I am continuously examining my motives. I ask myself, "Why am I making this piece?" and "What am I hoping the outcome will be?" Approval, financial reward, and a love of the creative process are often strong motivations, but it's my hope to find inspiration and passion elsewhere. This is not always easy (especially when rent is due), but when everything comes together and a piece turns into a voice that challenges and empowers even one person, it is truly rewarding.

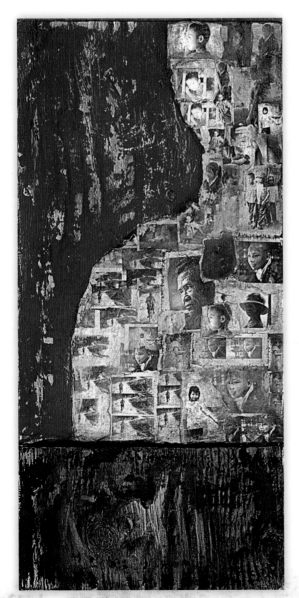

My artwork and life are intertwined. The work I put forth is reflective of my experiences. God is my greatest influence: When I take a photograph or pick up a paintbrush, I strive for those moments when I feel as though I am getting a foretaste of the divine—when I am gazing upon an existence grander than myself.

I believe artists should push themselves and their art forms, constantly looking for subtle—and at times radical—ways to improve their creative pursuits. It's easy to fall victim to routine and, in essence, become a factory worker who spends most of his or her time replicating a successful piece. This is when creativity and growth come to a halt. To avoid this outcome, you must intentionally continue to grow, expanding your range of knowledge and understanding of the art form, the message, and the delivery. Always work to advance in technique, and draw on passion and inspiration from a source outside of yourself.

—Isaac Anderson

Isaac's Palette

alizarin crimson, black, burnt umber, cadmium yellow, cerulean blue, Grumbacher's red, Mars black, raw sienna, raw umber

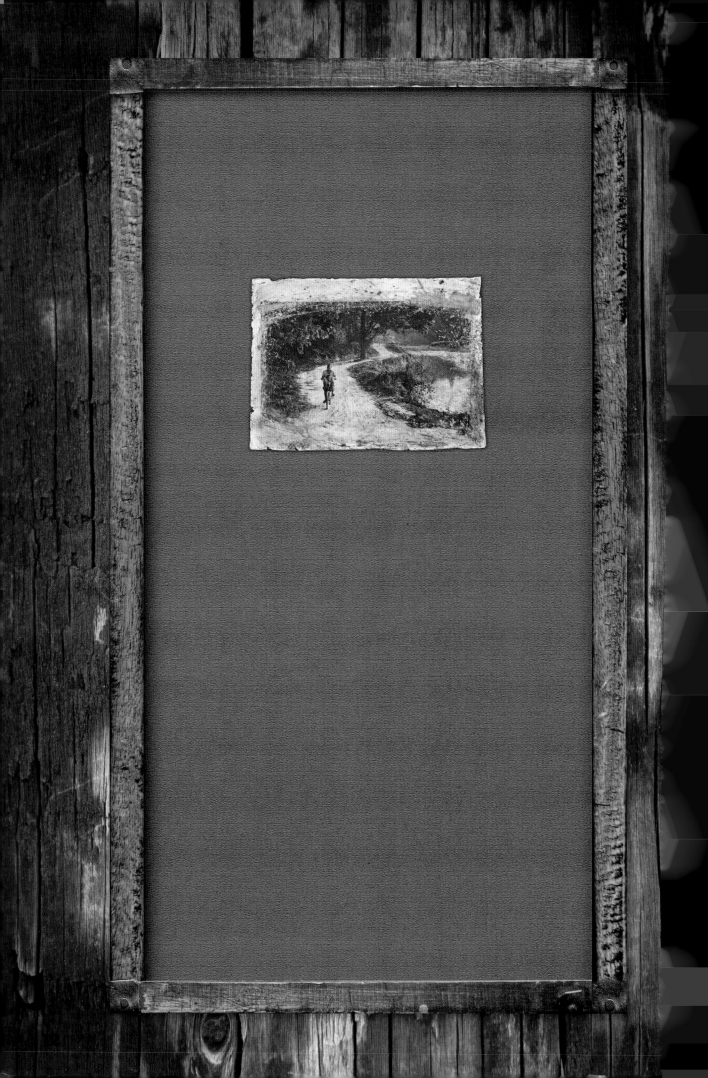

Weathered Photo

The photograph I used for this project depicts a journey—not just of a woman and her child, but also of a culture in Southeast Asia. The woman is riding alongside a river that serves as a border between Thailand and Burma. Although the river is small, it can feel like an ocean standing in the way of freedom and hope to the people of Burma. The goal of this project is to tell a story that challenges the artist and the storyteller, whether it's about the plight of the Burmese or the innocence of a child.

Materials

- 40-grit sandpaper
- 80-grit sandpaper
- Acrylic gel medium
- Acrylic paint (See "Isaac's Palette," page 11)
- Digital or print photograph
- Neutral-pH acid-free adhesive, clear-drying white glue, or wood glue
- Paintbrush
- Water-resistant protective sealer for photographs
- White copy paper
- Wooden panel or frame
- Clean cloth or paper towels

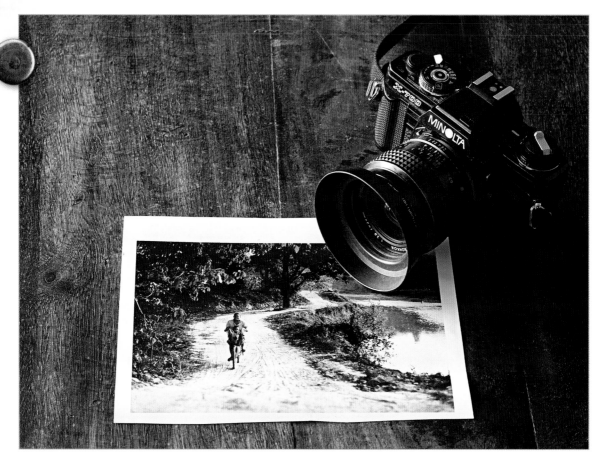

Step 1 Select a photograph suited for weathering. A luster or matte finished print is ideal, but a glossy print will also work. I used a 35mm negative that I scanned and printed on a mildly textured luster paper with a photo-inkjet printer.

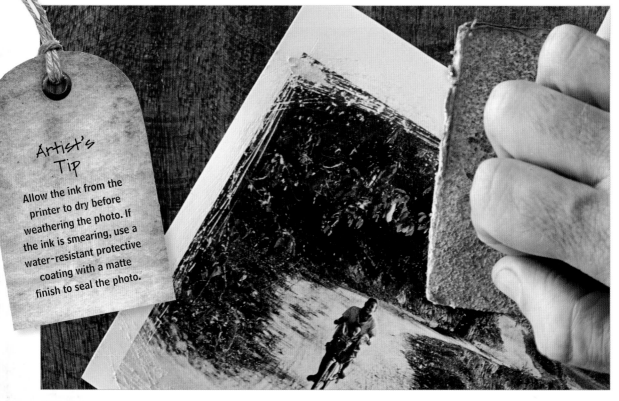

Step 2 With 80-grit and 40-grit sandpaper, lightly sand the edges of the photograph, mimicking the wear a photo might incur if it were several decades old. (It's best to sand a couple of practice images first.) Sand through the finish in several places to reveal the fibrous paper beneath.

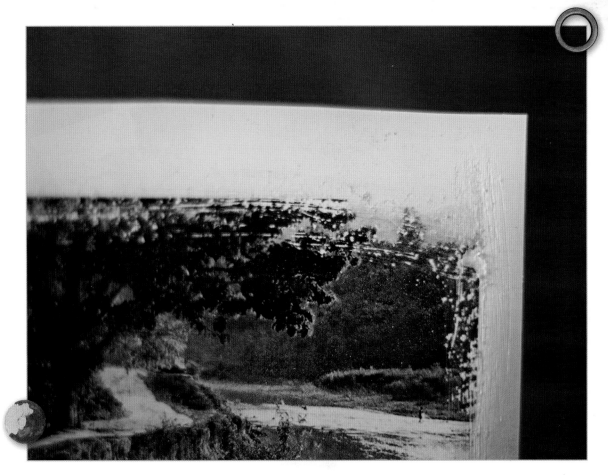

Step 3 Place the photo on a rough surface, such as concrete or asphalt, and continue to sand the edges to create textured wear. Sand all the way through the image in select areas until the desired level of distress is achieved.

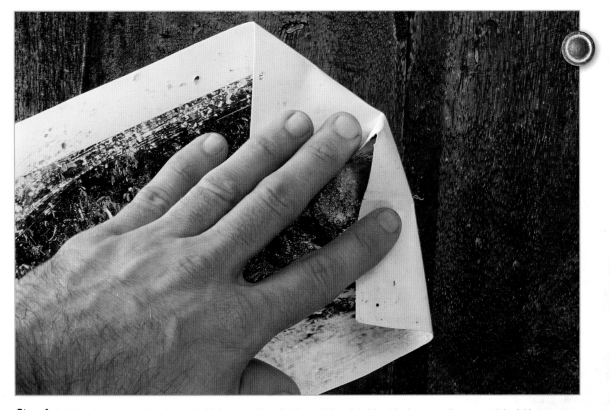

Step 4 Fold the photo to age it further and add character. Next, lightly sand the print side of the image on the crease of the folds to create defined wear marks.

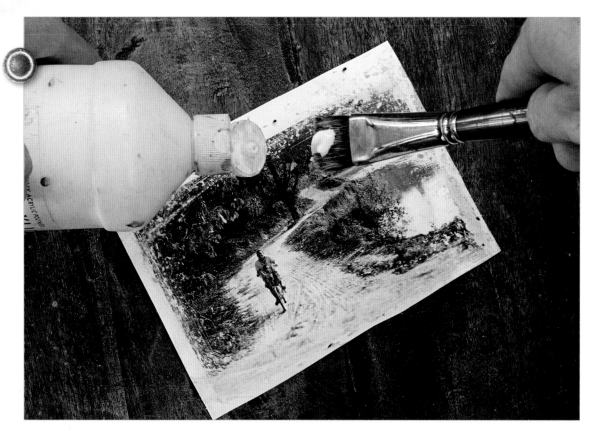

Step 5 Brush clear-drying acrylic gel medium onto the image's surface. A thick coat of medium will have more texture, but it will also take longer to dry. Use a hair dryer to speed up the drying process, if desired.

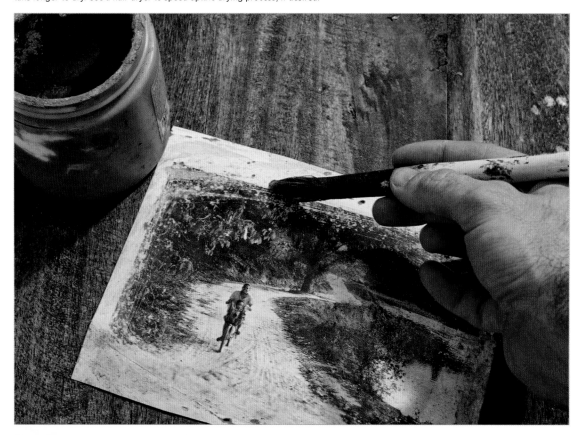

Step 6 Create a mixture of raw sienna acrylic paint and water. Using a paintbrush, apply a light coat of the mixture over the photograph. Use a clean, soft cloth or paper towel to lightly wipe off a bit of the color before it dries. The paint will settle into the distressed groves, causing the image to look stained and faded.

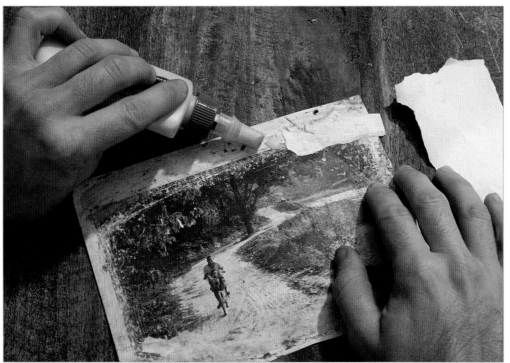

Step 7 Tear off several small pieces of plain white paper. Use a clear-drying white glue or wood glue (which will add a slight yellow tone) to adhere the ripped paper to less important areas of the photograph.

Step 8 After the glue has dried, brush a small amount of water over the strips of paper. Next, lightly rub the paper with your fingers so that it begins to dissolve. Continue to rub until the desired amount of paper has been rubbed off of the photograph.

Adding Texture

If additional texture is desired, apply more white glue or wood glue to the surface of the image.

Step 9 When the glued paper strips are dry, apply a layer of the raw sienna mixture to discolor them.

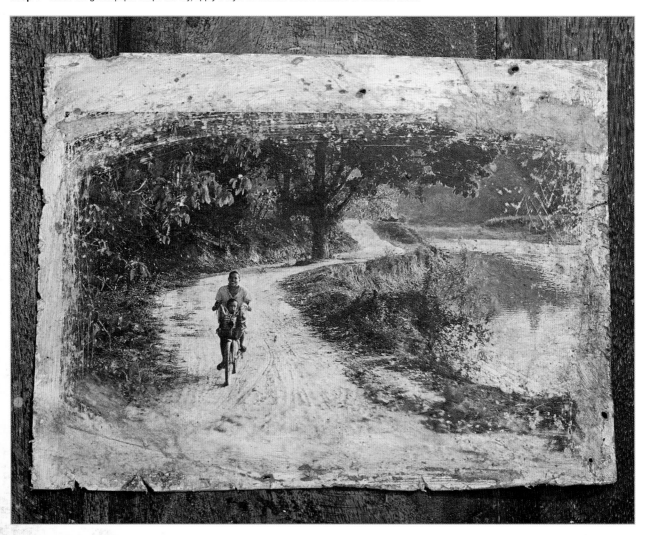

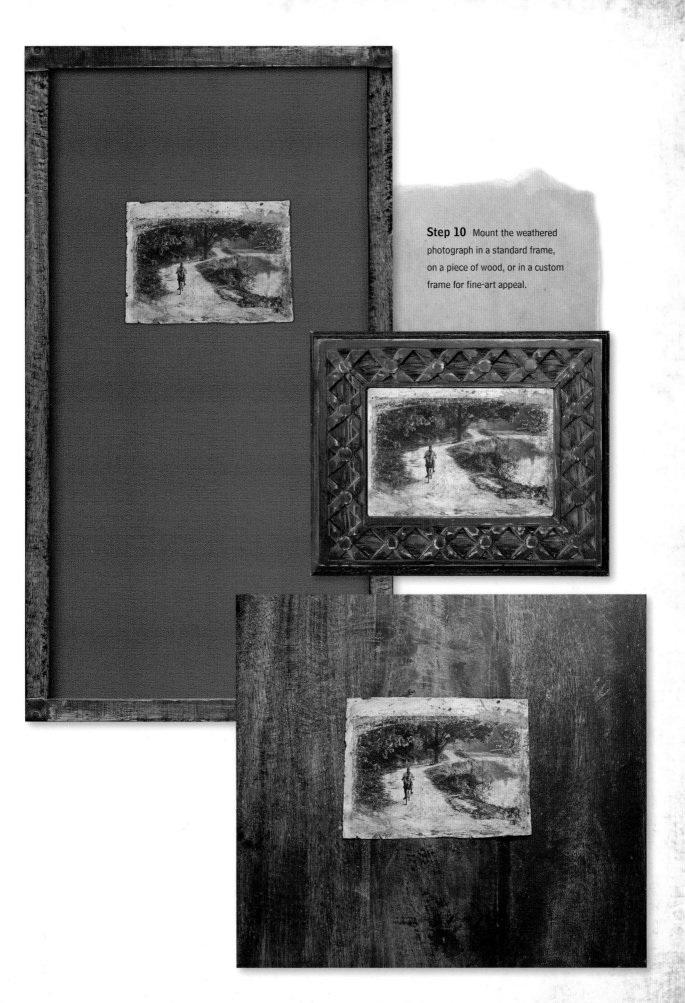

Step 10 Mount the weathered photograph in a standard frame, on a piece of wood, or in a custom frame for fine-art appeal.

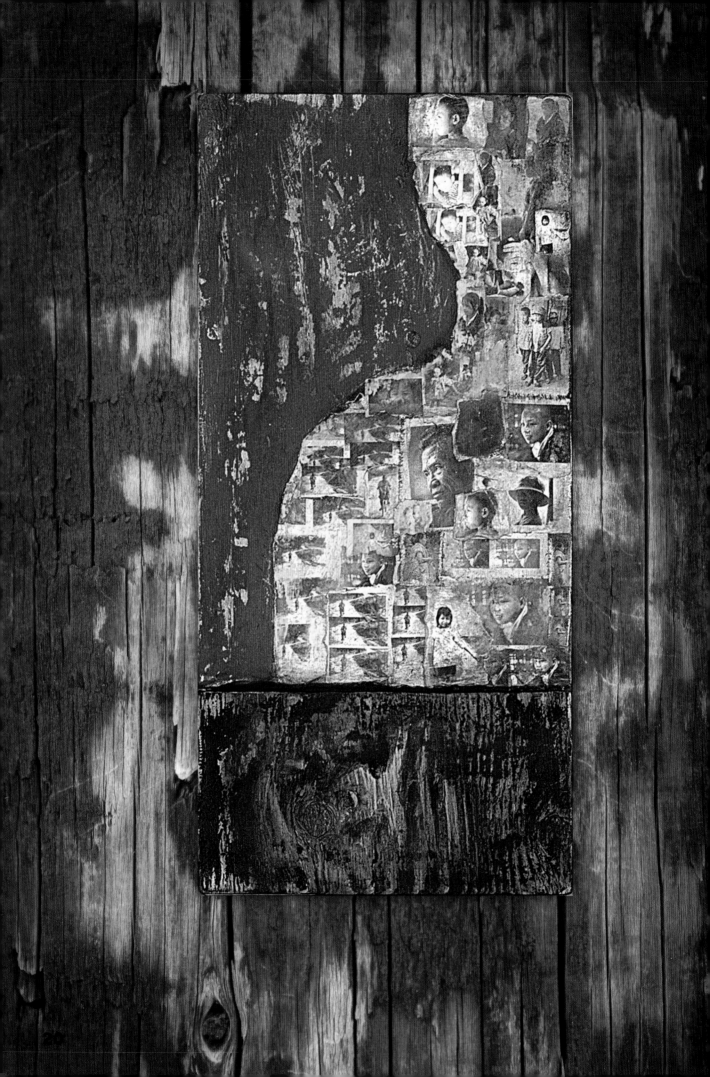

Story Assemblage

For this project, I assembled a collection of photographs I took in Burma into a single image that tells the collective story of the people who live there. From the texture of the wood to the color of the paint and the layered images, this piece is intended to represent the subjects' resilience and fortitude.

If you possess a collection of photos that tells a powerful story, I hope this project inspires you to assemble them in such a way that you can express the depth of the relationships, experiences, and stories they portray. Acrylic and oil-based paints are both suitable for painting between and over photographs. I used acrylic.

Materials

- 60-grit sandpaper
- Acrylic glazing liquid
- Acrylic paint (See "Isaac's Palette," page 11)
- Chisel
- Hammer
- Hand saw
- Inkjet printer
- Neutral-pH acid-free adhesive, clear-drying white glue, or wood glue
- Pencil
- Photographs printed on textured surface or distressed photographs (See "Weathered Photo," page 13)
- Plain matte papers and/or water-resistant, archival canvas sheets
- Water-resistant protective photograph sealer
- Wood panel

Step 1 Print a selection of digital images on a textured surface of your choice. I use my inkjet printer to print images on luster and plain matte papers, as well as canvas sheets. Seal the ink using a protective coating; then follow the directions on pages 14–18 to weather your photos.

Step 2 Select a wood panel for the foundation. I used a piece of reclaimed weathered plywood with a texture I felt would best support my images and the story I wanted to tell.

Step 3 Next, mark off the area or areas on the panel where you are going to adhere your photographs. I oriented my panel vertically and marked off the lower third with a horizontal pencil line. The upper two-thirds of the panel will be reserved for the photo and paper elements.

Step 4 Use a hand saw to cut a $1/8$-inch-deep groove along the penciled horizontal line.

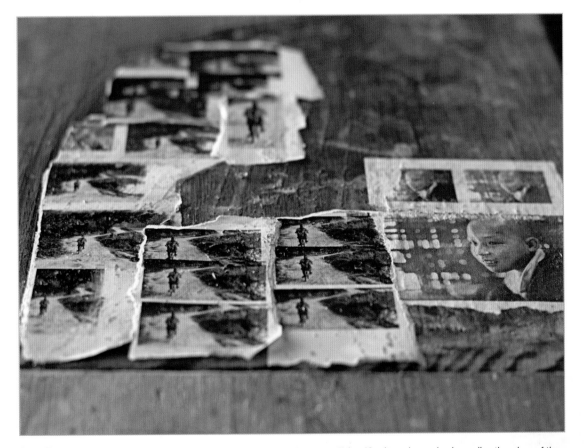

Step 5 Tear each print according to the shape and size desired for placement. Using 60-grit sandpaper, begin sanding the edges of the prints on a slightly rough surface, so that the pictures begin to fade and wear in an uneven yet natural fashion. Arrange the photos on your panel.

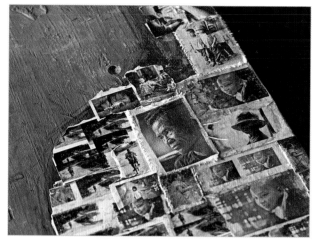

Step 6 Apply a neutral-pH acid-free adhesive to the wood panel and to the backs of the photographs. (You may also use white glue or wood glue.) When the glue is slightly tacky on both the panel and the photographs, begin to adhere the images to the foundation in an arrangement that best tells your story. This is where you will give your images a "voice."

Step 7 After the images are assembled, begin covering the negative space on the panel with acrylic paint. This may require several coats in areas where different colors are layered. To achieve a stained appearance, dilute the paint with water and apply a thin wash. I layered two shades of red paint on the upper portion of the panel and used a light coat of black paint on the lower portion of the piece. Notice how my images form a larger representational figure, while leaving other parts of the panel open.

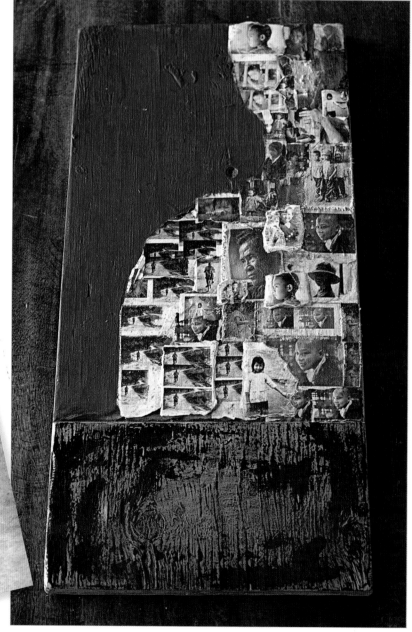

Artist's Tip

Allow plenty of drying time between coats of paint; otherwise the colors may become muddy.

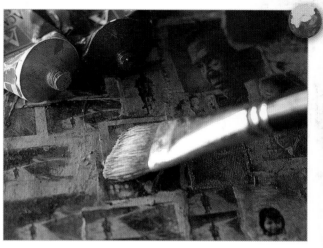

Step 8 When the paint is dry, begin to sand and scrape through its surface, revealing the aged wood beneath. You may also choose to hammer, scrape, and scratch the wood to age it further. (This is also good for blowing off steam!) I scraped through the paint using a chisel and 60-grit sandpaper.

Step 9 Employ various weathering techniques to further distress your assembled images as desired, experimenting with different materials and methods. Use a paintbrush to dab warm-toned yellow acrylic paint over select areas. Paint over some images with an opaque coat and leave others with a translucent tint to further augment your art.

Step 10 Once the piece has thoroughly dried, apply an acrylic glazing liquid (matte, satin, or glossy finish) over the entire surface. If the piece will be exposed to sunlight, use a coating that contains UV inhibitors.

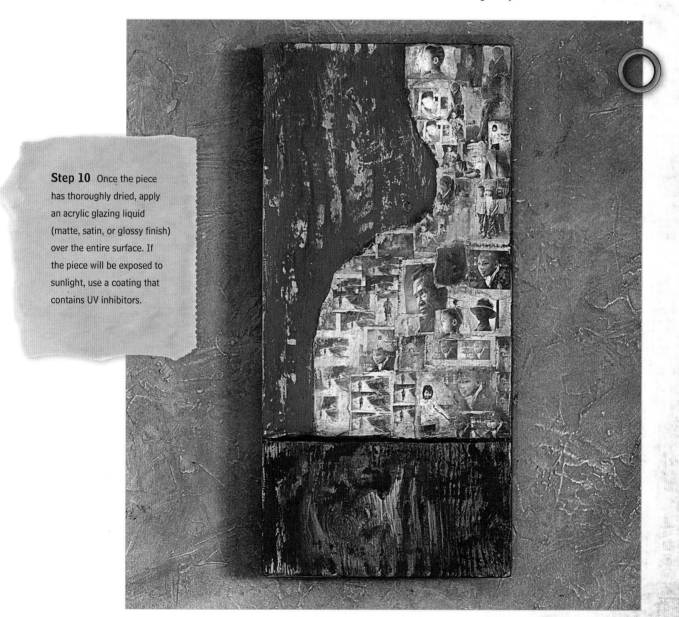

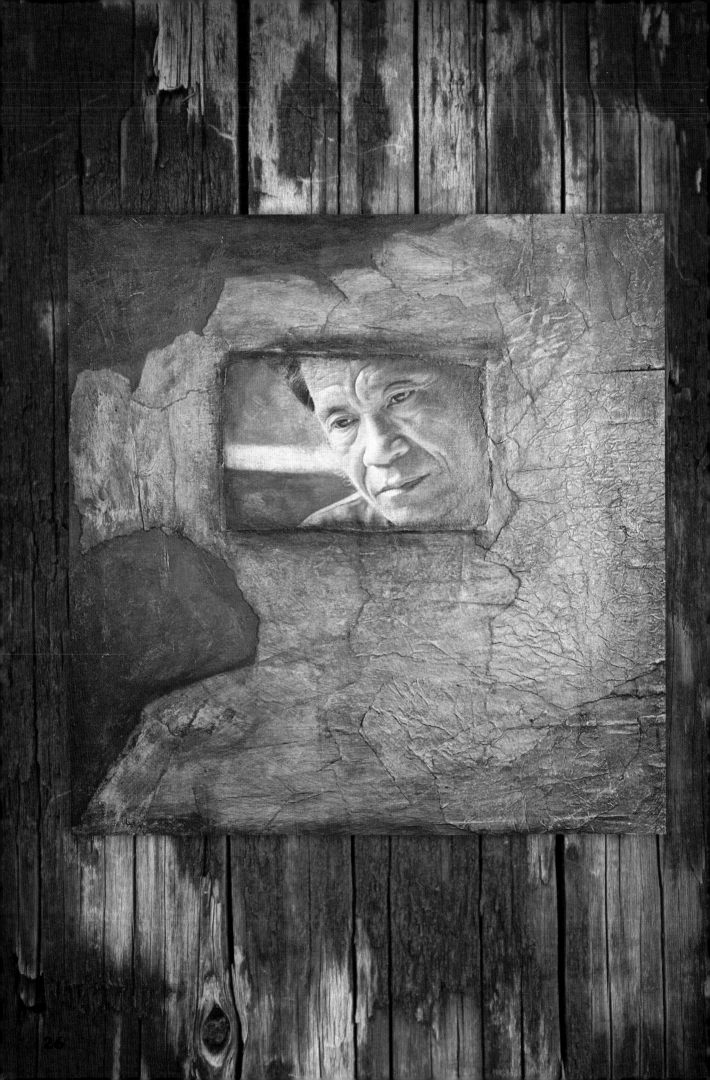

Single Focus

This project features an image of a Southeast Asian man who lost his son to the military regime in Burma. I interviewed and photographed him in a refugee camp on the Thai-Burma border. I was extremely moved by his story of loss. For this project, use a significant image with a variety of textures and materials to tell a story that might otherwise be lost. This project is dedicated to the people living in the Mae La refugee camp, who are hoping to one day return to their homes in Burma.

Materials

- Acrylic medium (for thinning)
- Clear matte finish
- White glue
- Inkjet printer
- Neutral-pH acid-free adhesive
- Paper and fabric scraps
- Water-resistant protective photograph sealer
- Sandpaper
- Cloth
- Water-resistant archival canvas sheet
- Wood panel
- Acrylic paint (See "Isaac's Palette," page 11)

Step 1 Select an image that works well with the aesthetic of this project. I chose a black-and-white image that I printed on a water-resistant archival canvas sheet with an inkjet printer. If you choose this method, make sure your inkjet is suited for printing on thick photographic media. To prevent the photo ink from smearing, brush a light coat of the water-resistant sealer on its surface.

Artist's Tip

Local and online companies will print your images on canvas if you do not have the resources to do so. Just make sure that the surface of the canvas is matte or satin. Acrylic paints and mediums tend not to bond well to glossy surfaces.

Step 2 Select a wood panel on which to adhere your photograph with enough open space to surround the image with paper and fabric scraps. I used a 24-square-inch piece of 1/2-inch-thick hardboard from a lumberyard scrap bin.

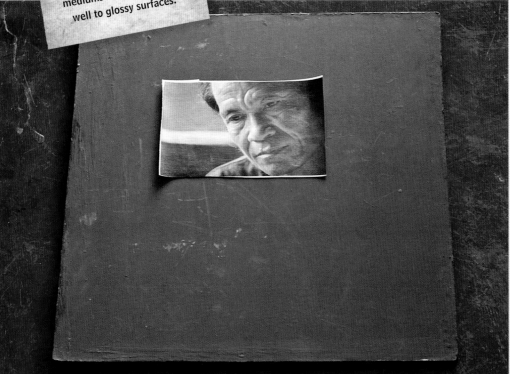

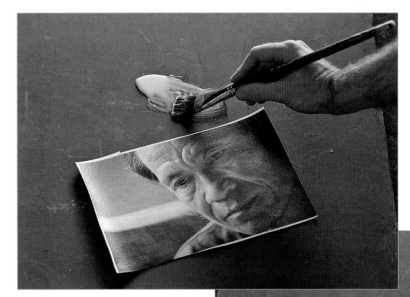

Step 3 Apply acid-free adhesive to the panel and to the back of the print. Once the glue is slightly tacky, adhere the image in the desired position.

Step 4 Gather fabric strips, burlap, newspaper, or other paper scraps that you can apply to the areas surrounding the image. Tear your paper or fabric into different shapes and sizes. Feel free to use a variety of materials, depending on the mood and message you wish to convey with your piece.

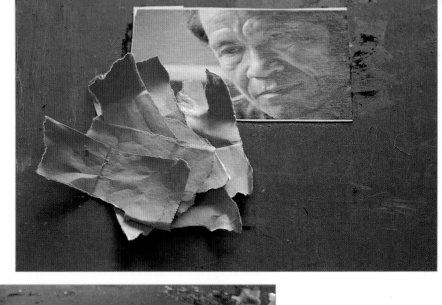

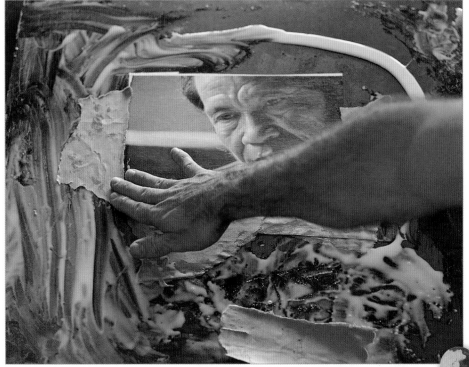

Step 5 Use white glue to affix the torn scraps onto the panel surrounding the photo, working outward from the image to the edge of the panel.

Step 6 Allow the paper and fabric scraps to dry to the touch, and then seal them with a thin layer of matte finish. Allow the entire panel to thoroughly dry in a well-ventilated area.

Step 7 Lightly apply an earth-toned patina to the outer textured media with a brush or cloth. I applied several shades of burnt umber, raw umber, and Mars black acrylic paint. Allow the first coat of paint to dry before applying more; otherwise the colors will blend and become muddy, losing their translucence. Next, thin the color a bit by dabbing over the surface with a damp rag. This will leave behind a more weathered patina that is darkest in the panel's recesses and faded on the ridges.

Step 8 Add acrylic medium to burnt umber for translucency. Employing the technique described in step 7, lightly paint the mixture over the photograph, allowing the image to show through. Wipe off excess paint with a cloth. The image will take on an aged appearance similar to the surrounding panel.

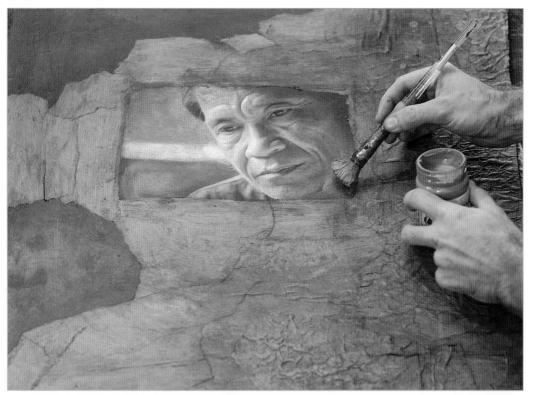

Step 9 When the piece is completely earth-toned, add a touch of bright color for visual interest. I added a coat of red and diluted cerulean blue. Once the colors dry, continue the patina effect on top of the image, being careful to allow adequate drying time between coats.

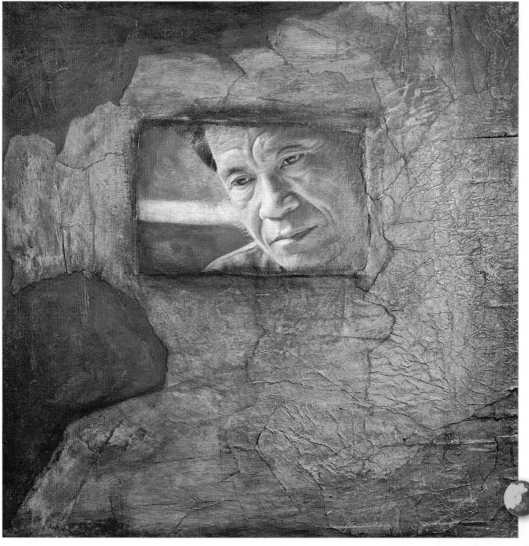

Step 10 Once the patina on the entire panel has dried, add a light, diluted coat of raw umber or a heavily diluted wash of Mars black. I added a mixture of these deeper hues on the bordering regions of the piece for additional contrast.

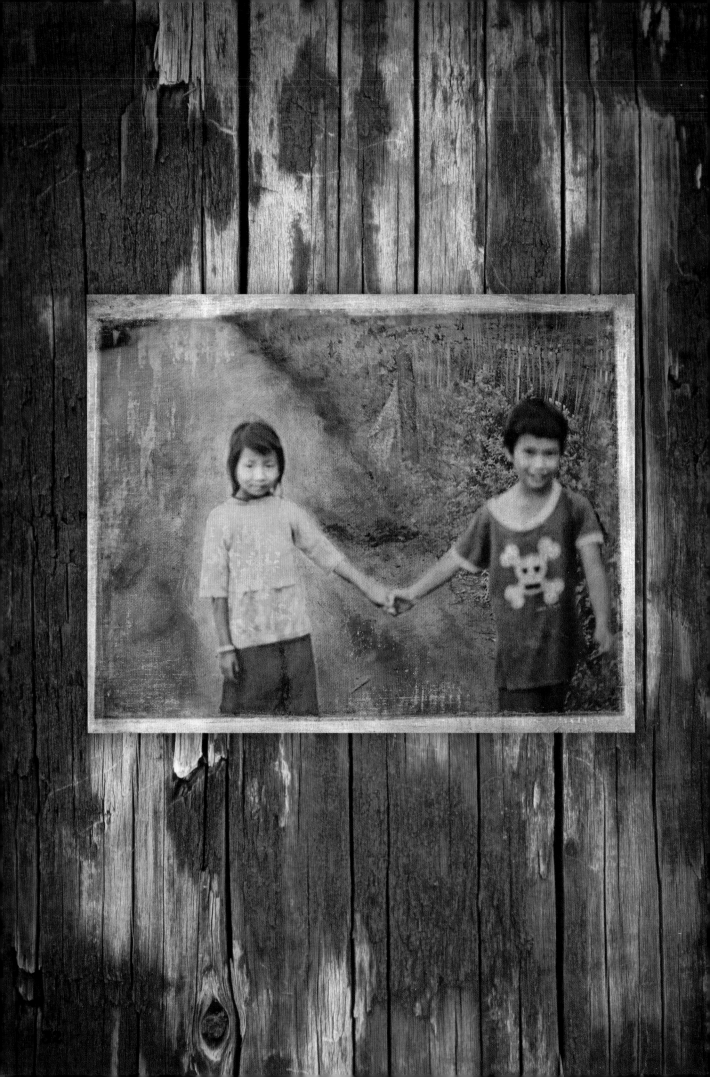

Painted Photo

This photo project features two children holding hands on a dirt road in a village in Eastern Burma. With the use of various mediums and paint, I tried to highlight a moment in the lives of two innocent children. The boy is on the move, and the young girl pauses to engage with me, a stranger in her struggling village.

Materials

- 80-grit sandpaper
- Acrylic glazing liquid (matte or satin)
- Acrylic paint (See "Isaac's Palette," page 11)
- Black-and-white photograph printed on a water-resistant archival canvas sheet
- Water-resistant protective photograph sealer

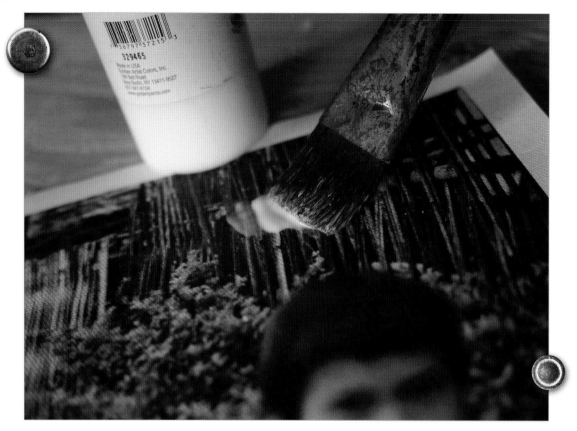

Step 1 Brush or spray a clear water-resistant protective sealer onto the surface of the printed image. When dry, prime your photo by painting the surface with a thin layer of acrylic glazing liquid.

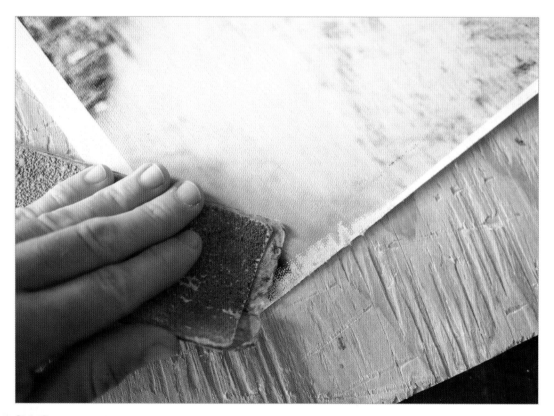

Step 2 When dry, lightly distress the canvas by sanding its edges with 80-grit sandpaper. I placed the canvas on a piece of weathered plywood to create a slightly uneven wear pattern. As you sand, the edge of the canvas will begin to fray. Feel free to pull the loose strands to add to the weathered appearance.

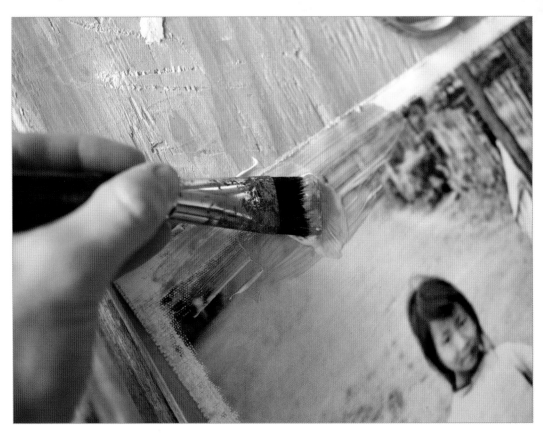

Step 3 Create a mixture of equal parts raw sienna paint and acrylic glazing liquid. Once the image is thoroughly dry, brush the mixture onto the print, concentrating the color in areas that you wish to have a drastically weathered appearance or a warm tone. For a translucent effect, add more glazing liquid to the mixture.

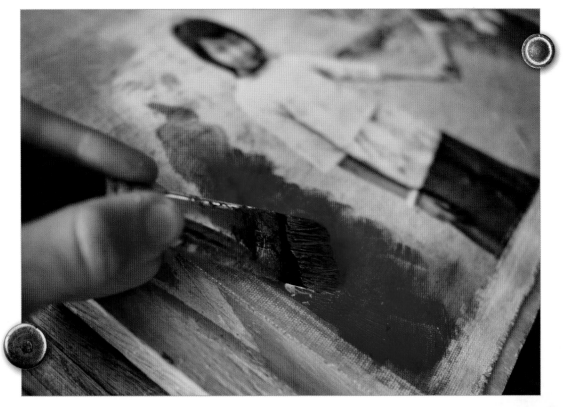

Step 4 Duplicate the previous step using different colors and varying amounts of acrylic glazing liquid. I mixed Grumbacher red with alizarin crimson for the dirt path. You may choose to mix the paint with a thicker medium, such a gel medium, to add more texture. Allow the paint to dry until the surface is tacky.

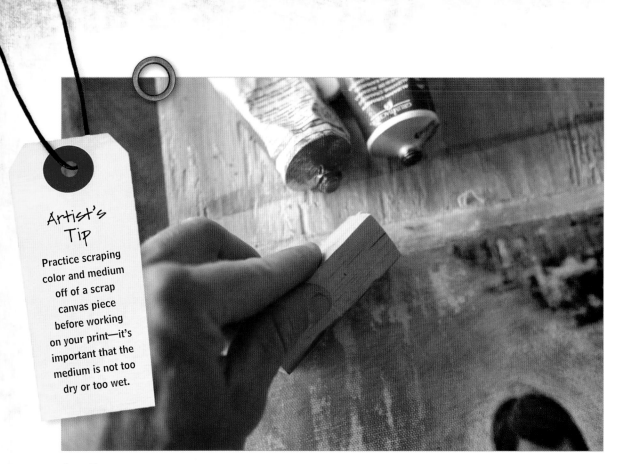

Artist's Tip

Practice scraping color and medium off of a scrap canvas piece before working on your print—it's important that the medium is not too dry or too wet.

Step 5 Use a rigid object, such as a small block of wood or a spoon, to scrape portions of color off the surface of the print. The colored medium will lift and flake, creating a unique distressed appearance.

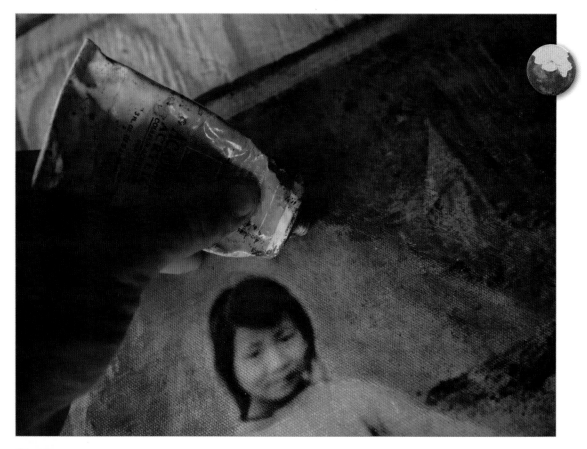

Step 6 Use the techniques described in previous steps to add color to the remainder of the image. I added more raw sienna and burnt umber to the edges and select portions of the print. I then added a touch of the cerulean blue straight out of the tube to create a more opaque and abrupt feel. I aged the image further by applying an acrylic medium and burnt umber over the top of the canvas, removing the excess with a cloth.

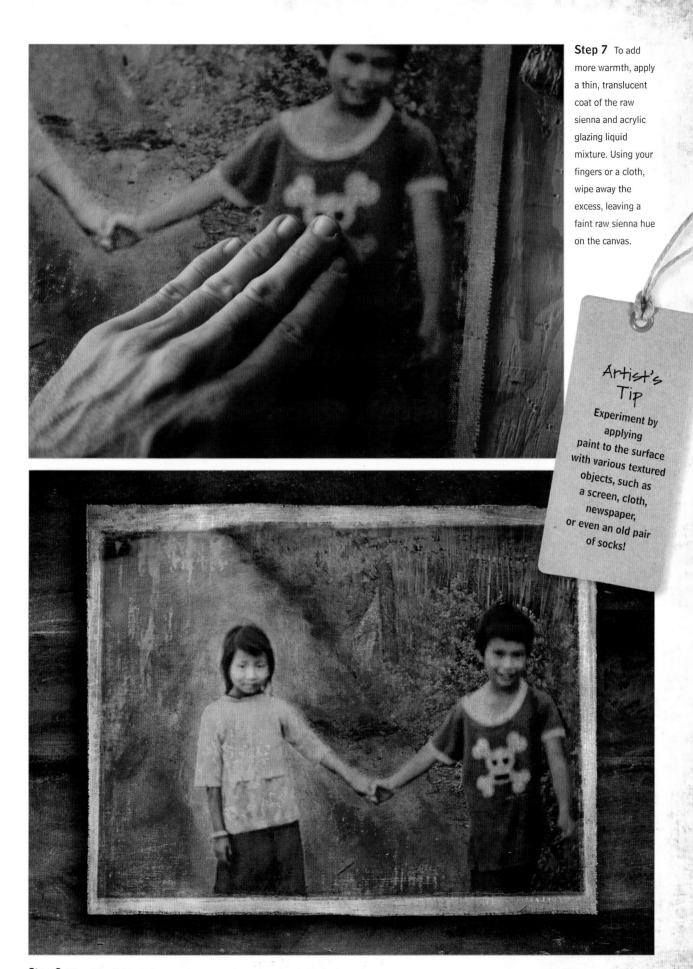

Step 7 To add more warmth, apply a thin, translucent coat of the raw sienna and acrylic glazing liquid mixture. Using your fingers or a cloth, wipe away the excess, leaving a faint raw sienna hue on the canvas.

Artist's Tip
Experiment by applying paint to the surface with various textured objects, such as a screen, cloth, newspaper, or even an old pair of socks!

Step 8 Mount the finished photograph to a panel, mat board, or behind a frame.

Mixed Media Collage

with Suzette Rosenthal

Suzette Rosenthal is a mixed media and fiber artist who lives and works in Laguna Beach, California. She has exhibited locally at various venues and has been an exhibitor at Laguna's famous Sawdust Art Festival for the past six years. Suzette has a BA in art from California State University, Los Angeles. From 1979-1981, she designed and produced a line of high-end knitwear under the "Suzette Sweaters" label.

When working with mixed media, Suzette is drawn to collage—using textures and color to create visual interest. She enjoys incorporating various found objects and recycled materials into her pieces. This, coupled with her strong sense of composition, gives her artwork unique appeal. It isn't necessary to replicate Suzette's designs exactly. When following along with the projects in this chapter, feel free to use papers and materials that are readily available in your home. Visit suzetterosenthal.com.

Inside the Artist's Studio

The reason I create art lies in the process itself. Working with the materials becomes a visual and tactile meditation—I completely lose myself in the moment. I enjoy using my hands to manipulate surfaces and the ephemera I apply to them, while allowing myself to get lost in the contemplation of each progressive step.

When approaching a blank canvas, the first thing I do is put a mark on it. What follows is a visual dance of give-and-take to turn that initial mark into a "resolved" composition. When creating small, abstract, or assembled pieces, I do not have an end result in mind. I let the piece evolve from what is

at hand. I have numerous ways of applying color and many boxes filled with "art fodder" that I pick and choose from. I love the idea of recycling and upcycling. Using a discarded item in a piece of artwork and making its original purpose unrecognizable gives me great enjoyment, especially when I surprise viewers by telling them what I've used. I also layer various techniques to give added depth and interest to the surface. I like the beholder to see something new with each viewing.

My approach is more controlled when creating still lifes and portraits. I fill the canvas with a rough sketch by zooming in on the subject to divide the picture plane into intriguing shapes. I often use collaged papers as an underpainting in some areas. Then I apply a base color with watercolor, acrylics, or pastels (or a combination of the three). Searching through my collection of art fodder, I find items I can layer to add texture, interest, or color. Some areas become flattened shapes; others become texturally dimensional. My goal is to create depth, textural interest, and a strong composition that draws the viewer in for a closer look.

I enjoy making art and being surrounded by the results of my endeavors. I also enjoy teaching others to unleash their creativity, especially those who don't think they are creative. I delight in seeing a student's surprise that he or she is making art.

—Suzette Rosenthal

Punchanella, stamps, stencils, found objects, random papers, magazines, foils, various writing instruments, and recycled items can be found among Suzette's art fodder.

Suzette's Palette

alizarin crimson, bright aqua green, burnt umber, cadmium blue-green light, cadmium green light, cadmium red, cadmium yellow, cadmium yellow light, cadmium yellow medium, cerulean blue hue, cobalt blue, deep violet, dioxazine purple, Hooker's green, iridescent gold, Mars black, quinacridone magenta, raw sienna, raw umber, titanium white, ultramarine blue

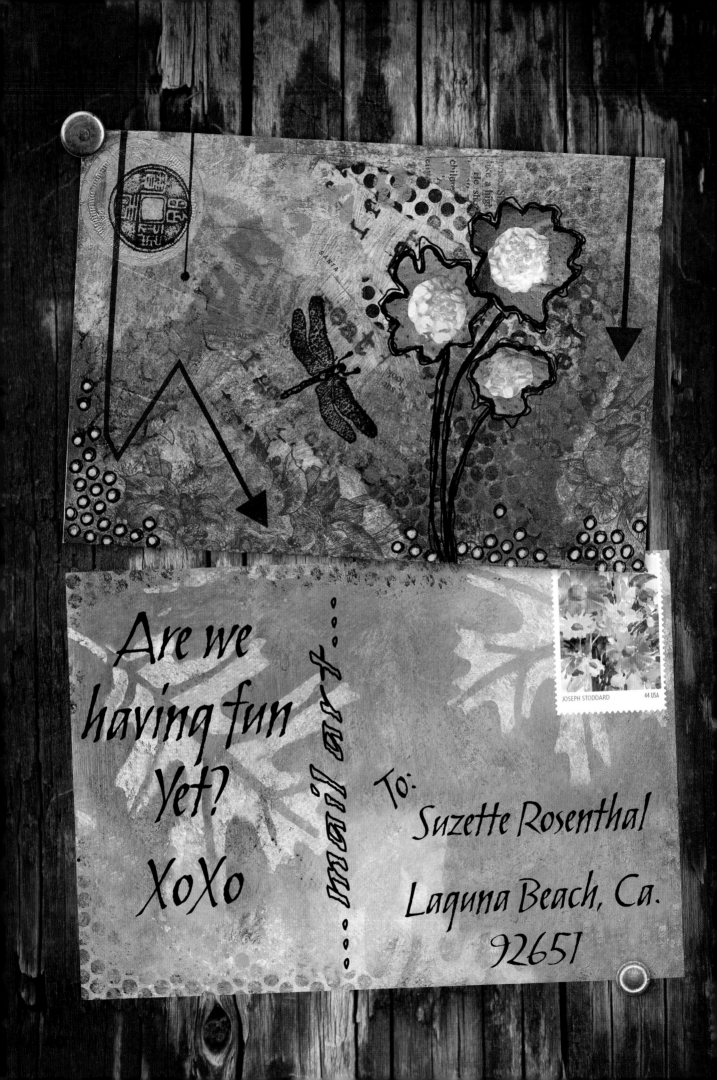

Mail Art

Mail art surfaced during the 1960s as a way to send small, whimsical, lightweight works of art through the postal system; today, it's a worldwide cultural movement. Any form of artistic expression can be drawn upon to create mail art for family, friends, and acquaintances. As you work through this project, you will learn to collage papers using acrylic matte medium, apply paint using various techniques, apply transparent collage elements, and create a focal point with added detail. Because this is a postcard, both sides will be decorated. When choosing a base for my mail art, I like to upcycle. I prefer mat board cast-offs from the local frame shop or cardboard. I stick to a 5" x 7" card size so that I can use a first-class stamp. Keep in mind that variations in the size and weight of your mail art will affect the cost of postage.

Materials

- Art fodder: magazines, printed paper napkins, printed paper, sewing pattern paper, sheet music, gold coin chocolate candy wrapper
- Acrylic matte medium
- Acrylic paints (See "Suzette's Palette," page 39)
- Black indelible pen
- Gold poster-paint pen
- Light blue poster-paint pen
- Mat board or cardboard for mail art support
- Porous dry sponge
- Rubber stamp (dragonfly)
- Stencils (leaf, numbers, punchanella)
- Stiff shorthaired paintbrush
- Squirt bottle
- Thick gel medium
- Yellow tissue paper

"Upcycling is the practice of taking something that is disposable and transforming it into something of greater use and value."
—coined by William McDonough and Michael Braungart, authors of Cradle to Cradle: Remaking the Way We Make Things

Art Side

Step 1 Begin by tearing contrasting papers into workable pieces. Use a paintbrush to apply a layer of acrylic matte medium to an area of your support. Lay a piece of paper on top of the medium, and then apply more medium over that paper. Continue this process until you are satisfied with the amount of paper on the support. It's not necessary to cover every inch. Use your finger to smooth out wrinkles in the paper. You will paint over this layer, so don't worry too much about the way it looks at this stage. Allow the support to dry.

Step 2 Using a stiff shorthaired brush and a dab of paint, scumble a thin layer of acrylic paint over the surface, pushing the paint into and around the surface. (See "Scumble," page 8.) If any areas resist the paint, dab a little paint onto the surface using a light bouncing motion, or scumble on additional layers. To remove excess paint, spray the surface lightly with water before it dries, and blot lightly with a paper towel.

Step 3 Use a paintbrush to apply ultramarine blue to one side of a small, dry, porous sponge. Gently stamp the bottom left area of the postcard with the sponge. Use a paintbrush to gently dab small amounts of alizarin crimson and bright aqua green onto the right side of a punchanella stencil; turn the stencil over and stamp the design onto the postcard to create a negative dots image. Paint the surfaces of several number stencils with a mix of bright aqua green, titanium white, and ultramarine blue; then stamp them across the top left. Paint a leaf stencil with cadmium yellow and apply the stencil to opposite corners. Cadmium yellow is transparent, so apply two layers.

Step 4 Next, create a floral motif on the lower portion of the piece. I used a printed paper napkin. Most printed napkins are composed of two to three thin layers, which are fused together at the edges. To separate the layers, roll the edges with your fingers or tear the napkin to reveal the layers; then pull off the printed portion. Transparent paper is fun to use, but it's fragile, so be gentle when brushing medium onto it. I used a dragonfly rubber stamp on sewing pattern paper, but feel free to use any transparent paper. I've brightened up the corners with yellow tissue paper.

Step 5 A group of flowers cut from magazine images is the focal point of this piece. Notice that the grouping is off-center, which keeps it interesting. I added a flattened chocolate gold coin wrapper to the upper left corner using thick gel medium. I added another piece of stamped sewing pattern paper over the coin; then I added arrows cut from sewing pattern paper. Cover the surface with medium as a protective coating.

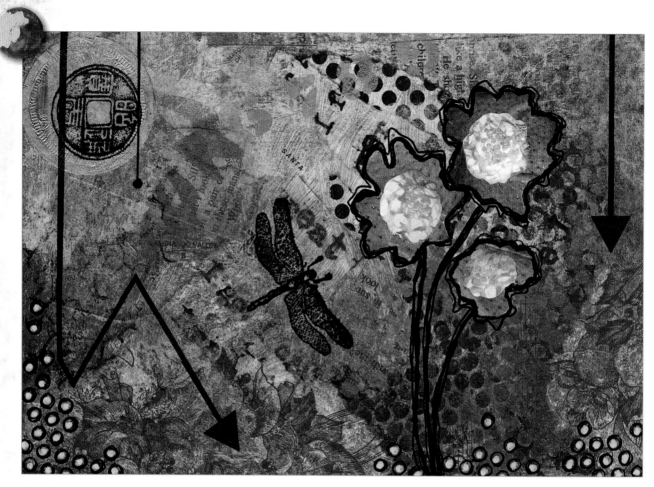

Step 6 Finally, use a black indelible pen to loosely outline the flowers, add stems, and accent the dragonfly's body. Use the punchanella to stencil black circles randomly along the bottom; then use a light blue poster-paint pen to add color. With a gold poster-paint pen, accent the flower centers and outline the gold foil. Allow the front side to dry completely before embellishing the address side of the card.

Address Side

Artist's Tip

Use a large piece of cardboard as a placemat beneath your work in progress. Use it as a palette, as well as to test color; check the amount of paint on your brush; and experiment with stencil, stamp, and paper transparency techniques.

Step 7 When dry, flip the postcard over and scumble on a thin layer of acrylic paint in the same colors used on the opposite side of the postcard. Mix the colors as they're applied, adding a second layer in various areas. Before the paint dries, lightly spray the surface with water and then blot with a paper towel. This technique lifts the paint where the water droplets land, yielding a speckled pattern.

Step 8 Using the punchanella and an oak leaf stencil, add slightly contrasting hues for visual interest. Remember: This is the address side of the mail art, so the background should be subtle.

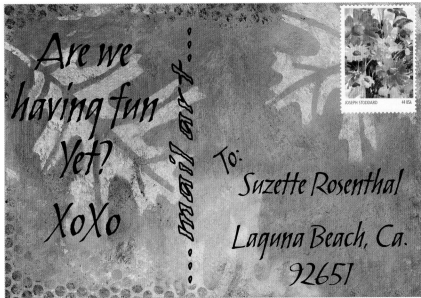

Are we having fun Yet? XoXo

... mail art ...

To: Suzette Rosenthal

Laguna Beach, Ca. 92651

Step 9 Add a stamp, your message, and the address. I like to indicate "mail art" in a separator line between the message and address areas. Now your card is ready to be sent! My mail carrier enjoys seeing my artistic mail coming and going.

Finding the Perfect Stamp

I buy decorative stamps online that fit the artistic theme of my mail art. For a variety of designs, visit the U.S. Postal Service website (www.usps.com). If you live outside of the United States, check with your local post office to see if designer stamps are available.

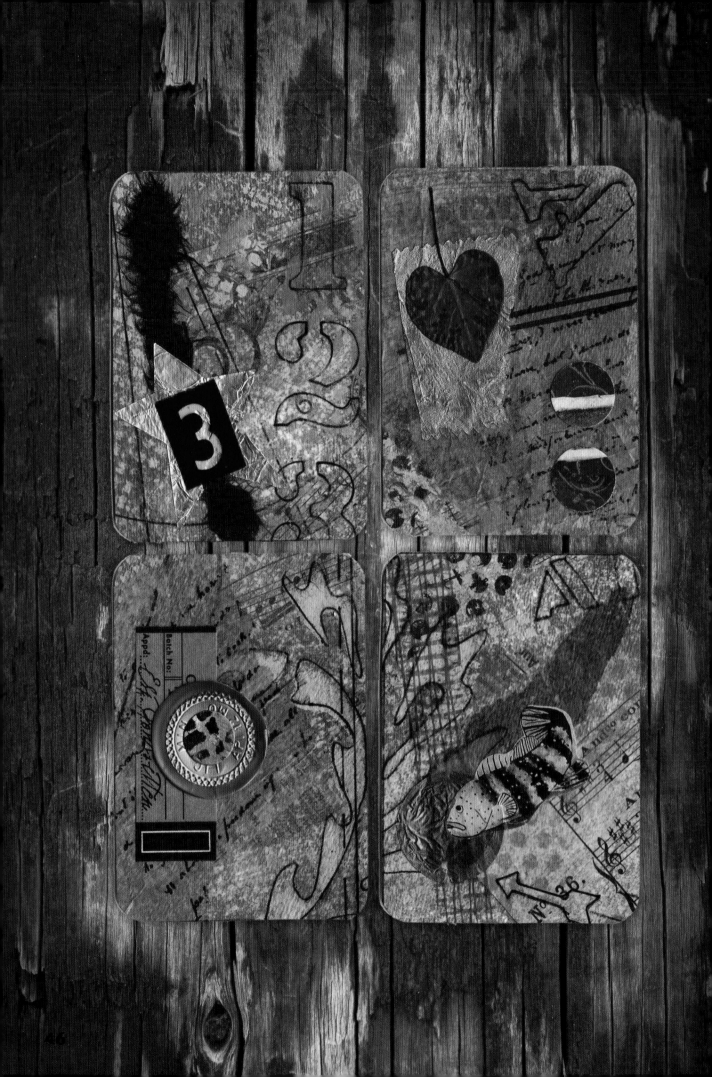

Artist Trading Cards

Artist trading cards are miniature works of art that artists create and trade with each other. They are the size of standard playing cards (2-1/2 by 3-1/2 inches) and can be made with almost any medium. The back of the card displays the artist's name, the medium used, the title, and the date it was created. This project begins with a large background, which will be cut into trading cards. Use the techniques from "Mail Art" on page 41 to help you with this project.

Materials

- 140lb watercolor paper
- Acrylic matte medium
- Art fodder: foil, magazine images, printed papers, sheet music, sewing pattern paper
- Black indelible pen
- Stencils (flowers, letters, punchanella)
- Heavy gel medium
- Rubber stamp (handwritten text)
- Squirt bottle
- Window screen pieces
- Plastic woven produce bag
- Acrylic paints: See "Suzette's Palette," page 39

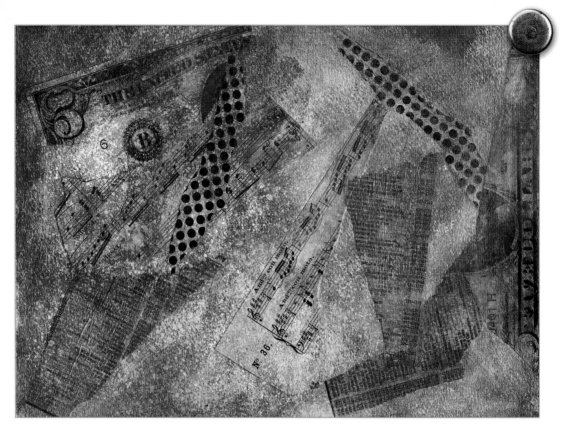

Step 1 Use a 9- by 12-inch sheet of 140lb watercolor paper as your base. Tear your paper materials into workable pieces. Apply a layer of acrylic matte medium to an area of your base, add a piece of paper, and then apply more medium over the paper. Continue this process until you achieve the desired look. Smooth out any wrinkles in the paper, and allow it to dry. Next, scumble a thin layer of acrylic paint on top of the collage. (See "Scumble," page 8.) I used a mix of raw sienna, titanium white, and burnt umber. Experiment with blotting and scumbling until you like the appearance of your background.

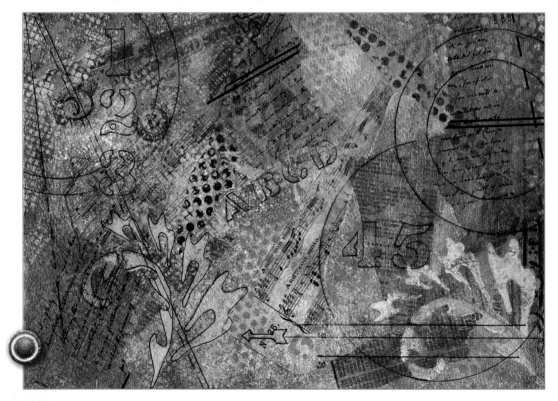

Step 2 Use acrylic paint to add floral and letter stencils to your background. I also used a punchanella and a plastic woven produce bag. Draw lines, circles, and numbers with a black indelible pen. To complete the background, I added sewing pattern paper—which becomes transparent with medium—imprinted with a rubber stamp of handwritten text.

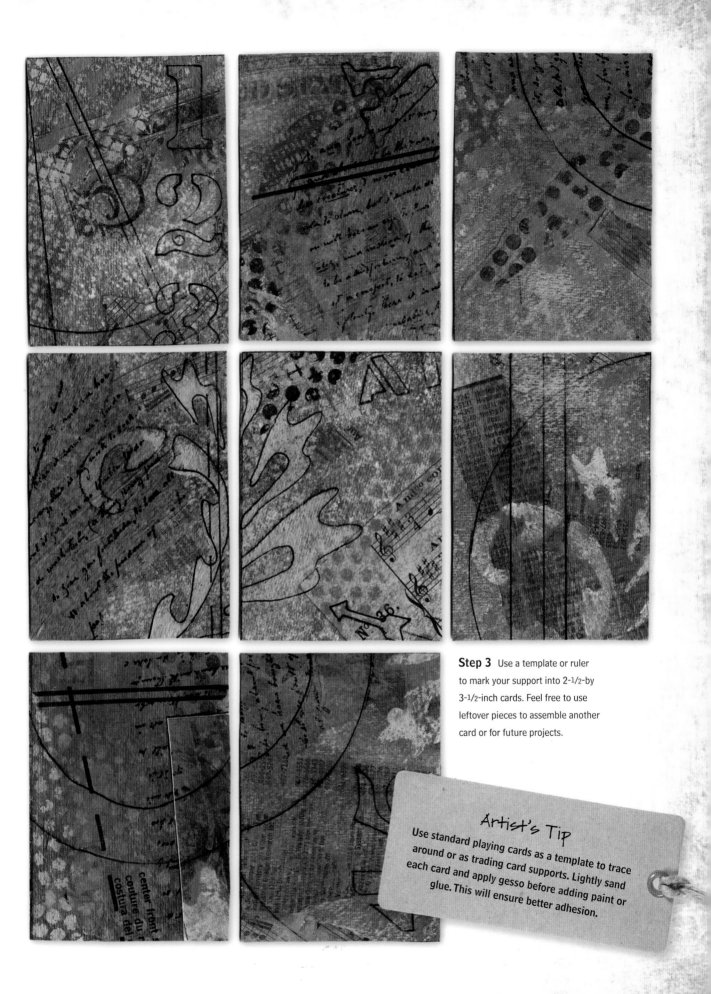

Step 3 Use a template or ruler to mark your support into 2-1/2-by 3-1/2-inch cards. Feel free to use leftover pieces to assemble another card or for future projects.

Artist's Tip

Use standard playing cards as a template to trace around or as trading card supports. Lightly sand each card and apply gesso before adding paint or glue. This will ensure better adhesion.

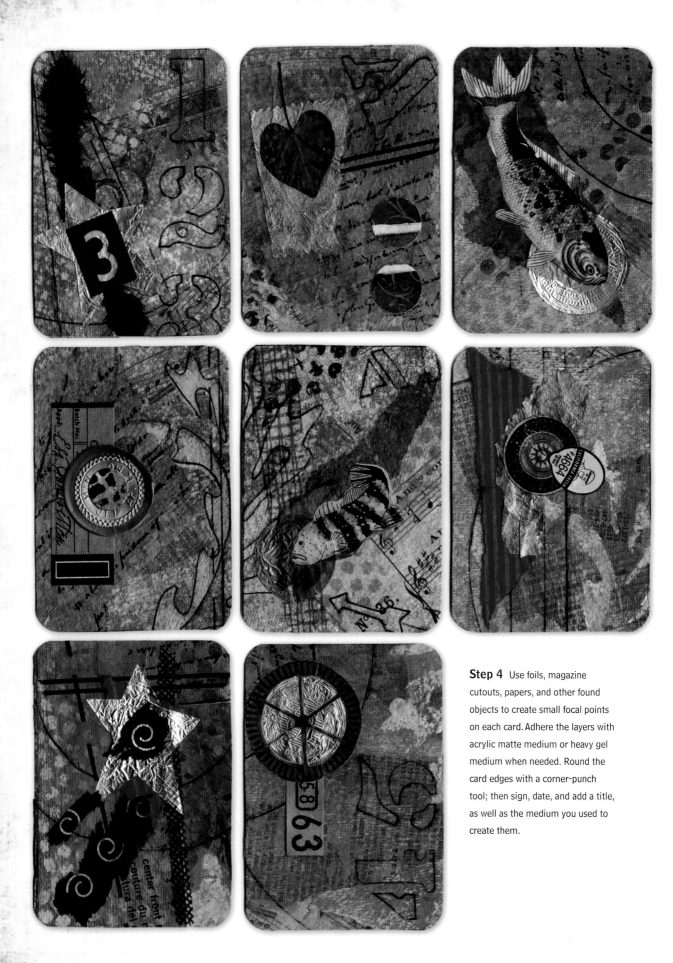

Step 4 Use foils, magazine cutouts, papers, and other found objects to create small focal points on each card. Adhere the layers with acrylic matte medium or heavy gel medium when needed. Round the card edges with a corner-punch tool; then sign, date, and add a title, as well as the medium you used to create them.

Idea Gallery

You don't have to create a large background every time you want to create an artist trading card. I made each of these cards individually. It was fast and fun!

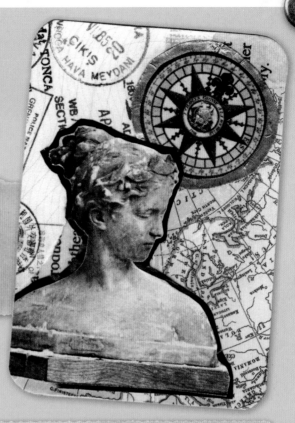

Junk Mail I created the background of this card from junk mail and the page of a book. For focal points, I glued a compass image to candy foil and a sculpture image to a black background.

Paper Collage For this card, I collaged torn paper, foil, tissue, and sewing pattern paper onto the background. I then added a magazine image of a stack of pillows for the focal point.

Pen & Paint The card at right was created by scumbling and stenciling acrylic paint onto the card's base. I then added highlights with a gold pen.

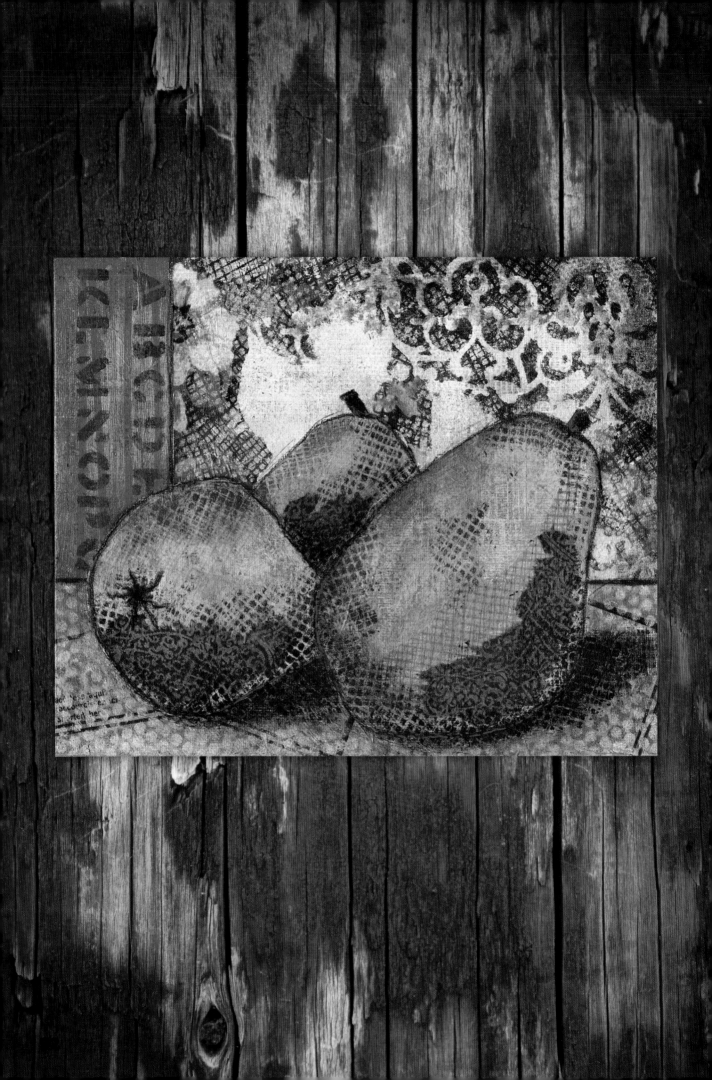

Still Life

A still life is a picture of inanimate objects that have been artfully arranged to create an interesting composition. The choice of objects, their juxtaposition, and the way the artist portrays them can give added depth and meaning to little slices of everyday life. When I re-create a still life, I like an "up close and personal" viewpoint, with the subject occupying most of the picture plane.

Materials

- Acrylic matte medium
- Acrylic paints: See "Suzette's Palette," page 39
- Art fodder: doily, green and yellow tissue paper, newspaper or phone book pages, printed paper napkins, sewing pattern paper
- Blue poster-paint pen
- Canvas board primed with gesso
- Charcoal pencil
- Gel medium
- Masking tape
- Old credit card
- Plastic woven produce bag
- Spray sealer or varnish
- Stencils (letters, punchanella)

Step 1 Use a canvas board primed with gesso as the base. Cover the canvas with acrylic matte medium. Then lay down a page from a phone book or a newspaper, being careful to keep the top of the paper free of medium. Use an old credit card to burnish the page down and remove air bubbles. Next, lay down strips of masking tape in a few places and burnish them down, as well. After a few minutes drying time, rip off the masking tape. This will pull the top layer of paper up, revealing the bottom layer and a torn edge. For more texture and interest, lightly spray with water and rub off additional layers.

Artist's Tip

For a composition with movement and visual interest, avoid placing the focal point in the center of your canvas.

Step 2 Scumble, rub, stipple, and blot titanium white over the surface in a thin layer. If this process creates an unwanted, gritty texture, lightly sand the surface and apply additional paint and a layer of acrylic matte medium to seal it. When dry, rough in three circles to determine the position of the pears. Draw a grouping of three, with each pear at a different angle. Complete the pears by adding stem and bottom details. Then draw a tabletop, which will serve as the horizon line, below the center of the canvas; then add a vertical line on the left side.

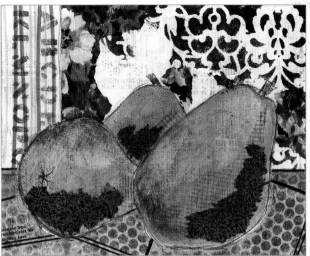

Step 3 Using cadmium blue-green light, Hooker's green, and cadmium yellow medium, scumble and stencil color onto the pears; then add a small red highlight for depth. Use different stencils to decorate each of the three areas in the background. I used a doily on the right side, letter stencils on the left side, and a punchanella painted with raw umber for the tabletop.

Step 4 Cut pieces of sewing pattern paper in a way that reveals visually interesting lines, and glue it to the tabletop with acrylic matte medium. Next, add small pieces of green and yellow tissue paper, woven produce bags (which may need gel medium for adhesion), and printed napkin to the pears in layers. Add printed tissue to other areas, as well, to soften the stenciled areas and create a layered look.

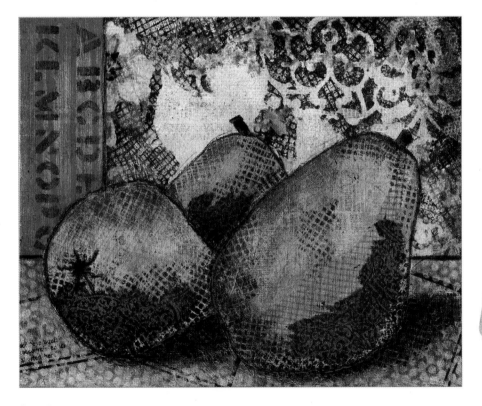

Step 5 Drybrush alizarin crimson over the letters. Whereas opaque colors will hide the background, colors such as alizarin crimson and cadmium yellow are transparent. Use a woven produce bag and the punchanella to stencil a bit of white into the doily and the tabletop areas, respectively. Using a charcoal pencil, draw thin lines around the pears and the stems, and then smudge the lines with your finger to accent the outlines of the shapes. Apply dioxazine purple, ultramarine blue, and alizarin crimson through the woven produce bag to create shadows on the table. Then use the same technique to add color to the pears using cadmium green light, Hooker's green, cadmium red, cadmium yellow, and a bit of ultramarine blue for accent. Next, add a bit of alizarin crimson to the upper left side of the work and a bit of dioxazine purple to the upper right side. Dab a bit of cadmium yellow on the tabletop and in the shadows. Draw a partial outline of the pears and stems with a blue poster-paint pen. This touch of a contrasting color will spice up the finished piece. Seal and protect your artwork with a layer of medium, spray sealer, or varnish.

Mixed Media Portrait

Oscar Wilde said, "Every portrait that is painted with feeling is a portrait of the artist, not of the sitter." A portrait may show the likeness of a person, but Wilde's quote implies it can speak more about the artist who created it than its subject. For this project, keep the initial drawing simple. Use an image that is in silhouette as a reference. Visual interest will develop as the portrait progresses.

Materials

- Acrylic matte medium
- Acrylic paints: See "Suzette's Palette," page 39
- Art fodder: gold foil, paperback book pages, sewing pattern paper, sheet music
- Cheesecloth
- Clear gesso
- Gel medium
- Gold poster-paint pen
- Photograph of the subject
- Plastic woven produce bag
- Pre-gessoed canvas board
- Rubber stamp (handwritten text)

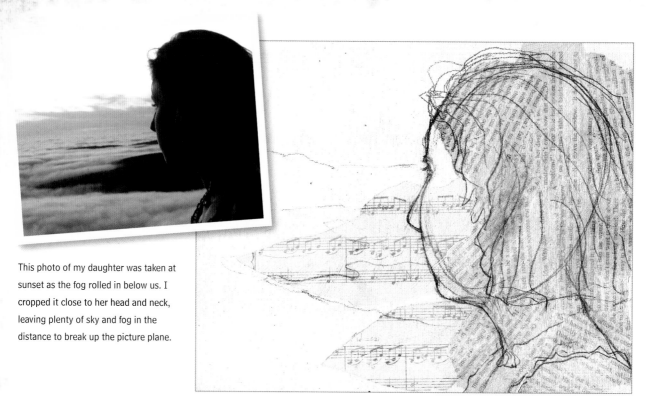

This photo of my daughter was taken at sunset as the fog rolled in below us. I cropped it close to her head and neck, leaving plenty of sky and fog in the distance to break up the picture plane.

Step 1 On pre-gessoed canvas board, use acrylic matte medium to collage sheet music and pages from a paperback book in areas where the head will be. Apply clear gesso over the paper for a muted, workable surface. Sketch an oval shape for the head, followed by the neck, hair, facial features, horizon line, and dark land areas. This divides the canvas into workable shapes.

Basic Face Proportions

This simple formula will help keep facial features proportionate in your drawings:

Step 1 Draw an oval.

Step 2 Divide the oval horizontally, creating the line that will go through the center of the eyes.

Step 3 Divide the bottom half of the oval, creating a line that will denote the base of the nose.

Step 4 Draw a line 1/6 of the way up from the bottom of the chin to serve as a marker for where the lips will meet.

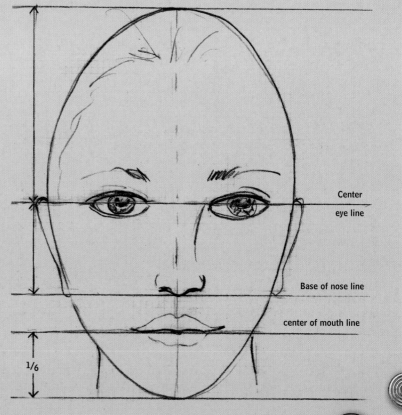

Center eye line

Base of nose line

center of mouth line

1/6

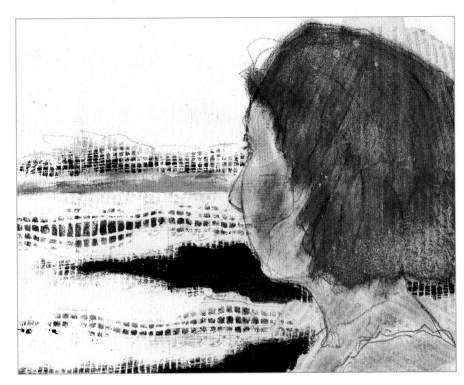

Step 2 Using a dry brush and different combinations of my basic palette (see "Suzette's Palette," page 39), scumble color onto the hair, face, and dark land areas. Use a woven produce bag to stencil in shadow areas.

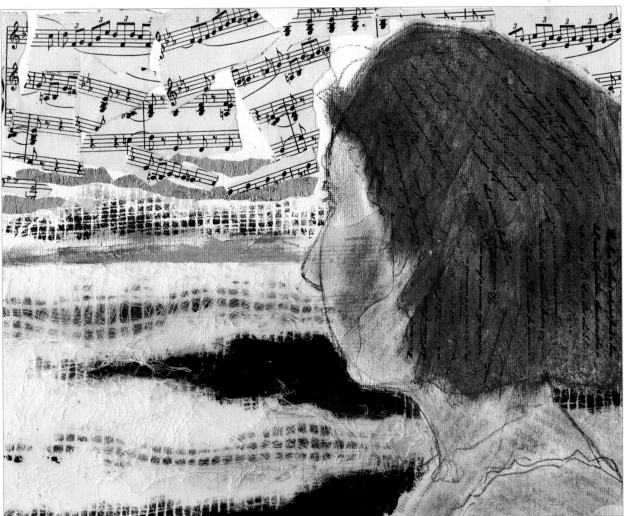

Step 3 Add more collage layers: I attached sheet music to the sky, sewing pattern paper, and bits of cut and torn cheesecloth to the fog areas. Adhere the cheesecloth with gel medium, and add small strips of gold foil to suggest the sun.

Step 4 Add more cadmium yellow to the sky for a sunset-like glow. Add a bit of blue wash to the head and alizarin crimson for more intense color.

▼ **Step 5** I like the subtle, muted colors of the original photo, so I toned down the sky and fog areas with white. Scumble white across the sky, and use the side of a brush to paint the surface of the cheesecloth in the fog. This allows the texture of the cloth and the underpainting to show through. Scumble iridescent gold over the sky to give it a golden glow, and use a small flat brush to paint a golden outline on the face, neck, and front edge of the hair. Apply another layer of white lightly over the gold. Then use Payne's gray with a fine brush to add the eye detail and straps. Finally, draw a few lines with a gold poster-paint pen to suggest wispy hair.

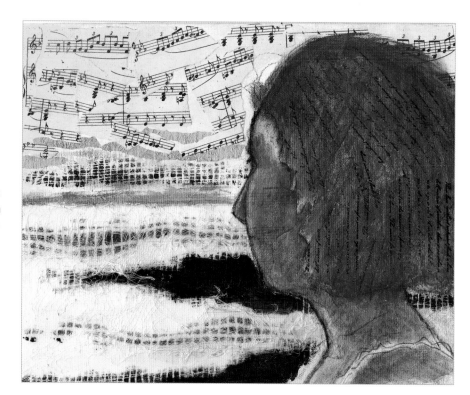

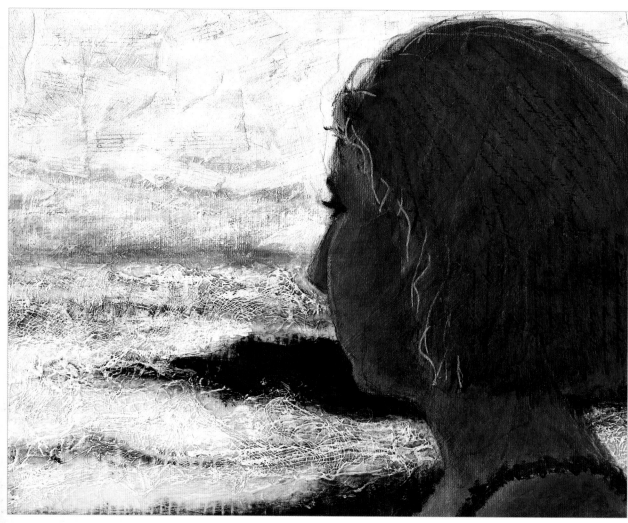

Advanced Portrait

I like the sense of mystery that a face in shadow presents. Although this is a dark photo, it still contains enough details from which to create a mixed-media work.

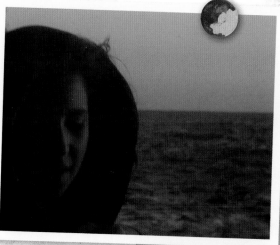

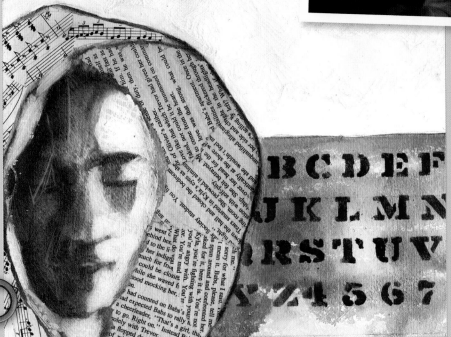

Step 1 First I sketched the image with charcoal and sprayed it with workable fixative. Next I added gesso to the highlighted areas for texture; then I collaged book pages and sheet music to the coat's hood and cheesecloth to the sky area. For interest, I stenciled letters into the water and added random washes of blue and purple. Using a woven produce bag, I stenciled pink highlights on the face.

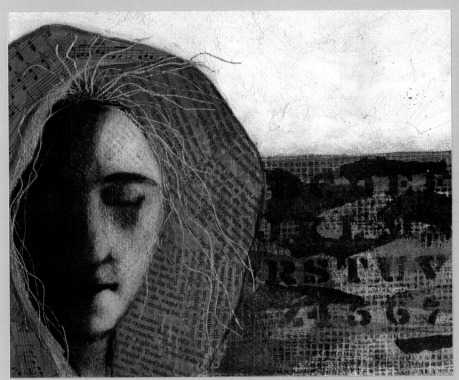

Step 2 I scumbled alizarin crimson over the hood, darkened the face shadows with more charcoal (and fixative), laid white onto the cheesecloth, and collaged three different shades of blue tissue paper over the water area. To add warmth, I scumbled cadmium yellow over the figure, along the horizon line, into the cheesecloth clouds, and onto the water. I then used a woven produce bag to stencil more alizarin crimson on the hood and more blue to the water. I also added a bit of blue wash between the clouds. For a final touch, I added wisps of golden hair with a gold poster-paint pen.

Abstract Assemblage

with Joe Martino

Ohio artist and resident Joe Martino sees a strong connection between science, creativity, and artistic expression. As a student at Kent State University and a graduate student at Akron University, Joe focused his studies on medicine and science, and he taught chemistry, anatomy, and marine biology to high school students for many years before retiring in 2009. However, Joe has always been an artist at heart. His paintings and palette have been described as "organic," a term he feels encompasses the essence of his work, as he is greatly influenced by science and nature. Joe has won numerous awards for his abstract paintings, and he was recently featured as one of Stark County's finest artists in the book *Stark ARThology*. Joe recently performed with the Canton Symphony Orchestra as an artist, completing four performance paintings on stage during live concerts that were part of its Kinder Concert Series. Joe's paintings are displayed in galleries in Canton, in private collections, and at the many art festivals in which he participates throughout the year. He currently lives and works out of his home in Louisville, where he resides with his wife, Gail, and their two cats. Visit www.joemartinoart.com.

Inside the Artist's Studio

I like to think of my abstract paintings as pure energy, movement, and emotion. They represent only themselves in meaning and significance, although sometimes they reflect the mood and understanding of the viewer. I particularly enjoy exploring and experimenting with design, color, and a variety of different media. My paintings are characterized by a sense of mystery that invites the viewer in. They often have a hint of realism hidden in the textures, colors, and shapes. I am always looking to stimulate an emotional response in the viewer. While spectators often inquire about the meaning and significance of a particular painting, the only meaning that matters is their response to it.

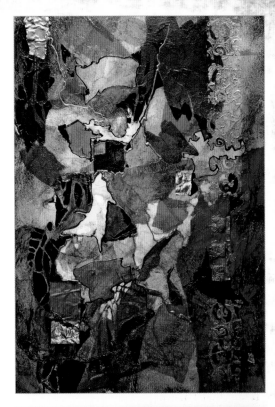

The discipline of content and composition is sometimes left to chance and may involve little structured direction. When I start painting, I usually have a few colors and textures in mind. I often begin by thinking about a warm or cool color and what materials are necessary for the initial texture. I then turn up the music, clear my head, and simply start to create. I work unpredictably and intuitively, responding to the rhythm of music I'm listening to and the direction the painting suggests to me. I constantly explore new ways to bring my painting to life. It often appears that the painting already knows its direction and that my duty is to listen, to surrender, to watch, and most of all, to trust my instincts.

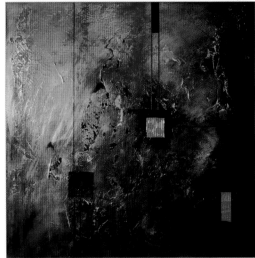

I usually work on two or three paintings simultaneously so that I can stay in the creative zone instead of waiting for paint to dry or gels to harden. I also constantly look at my pieces from different angles and different orientations. In fact, while I'm working, I probably spend as much time looking and viewing pieces from different angles as I do painting. Working on multiple projects also allows me to walk away from a particular piece, and then return to it with fresh eyes and a fresh perspective.

—Joe Martino

Joe's Palette

alizarin crimson, black, bright gold, burnt sienna, burnt umber, cadmium orange, cadmium red, cadmium yellow, copper, nickel azo red, nickel azo yellow, Payne's gray, phthalo blue, phthalo green, Prussian blue, quinacridone magenta, raw sienna, raw umber, Titan buff, teal, titanium white, ultramarine blue, yellow ochre, yellow oxide

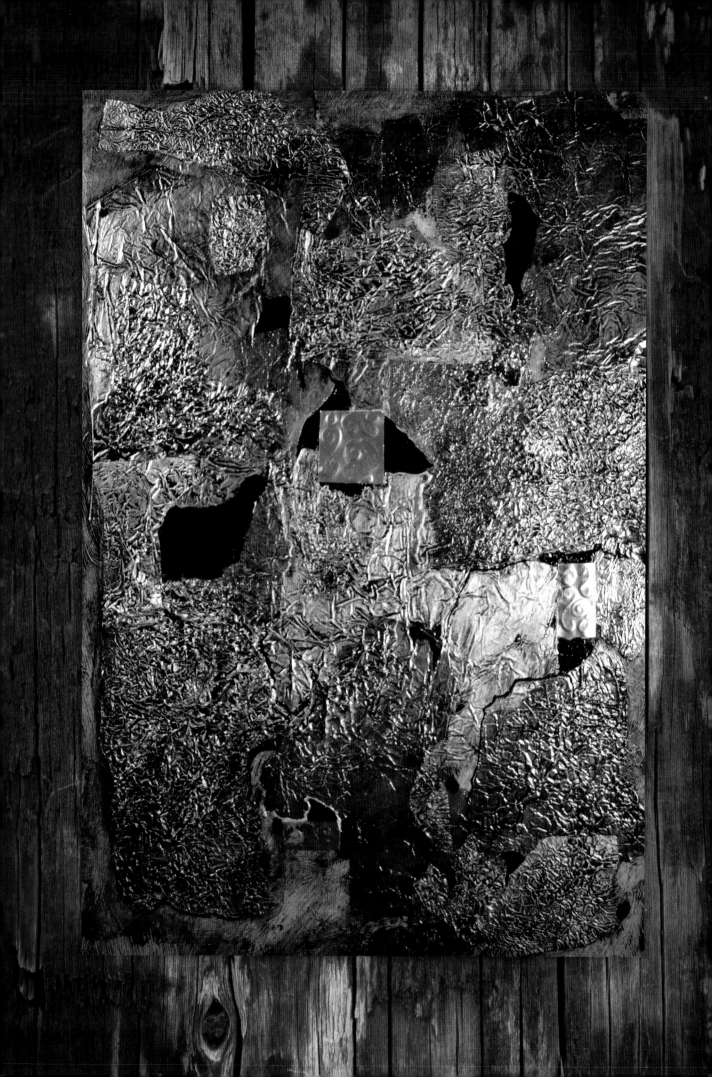

Foil on Illustration Board

This mixed-media painting employs foils and acrylic media on an illustration board surface. The painting begins with cool blue colors painted over a foil background, followed by layers of warm reds, yellows, and gold. Embossed brass metal pieces and metallic paint accents elevate the piece.

Materials

- Acrylic gloss gel medium
- Acrylic paints: See "Joe's Palette," page 63
- Aluminum foil
- Ballpoint pen or embossing tool
- Brass foil
- Gesso
- Gloss varnish
- Gold or other metal-based foil
- Illustration board
- Old candle
- Plywood
- Rubbing alcohol
- Sponge
- Squirt bottle
- Staples
- Tissue papers

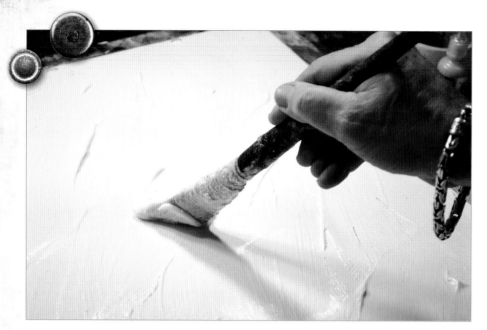

Step 1 Prepare the illustration board by waxing the edges with an old candle. This prevents the board from absorbing too much water and buckling. Coating the back with gesso and stapling the illustration board to a piece of plywood will also help to keep it flat and free of wrinkles during the painting process. Next, cover the surface with a thick coating of acrylic gloss gel medium.

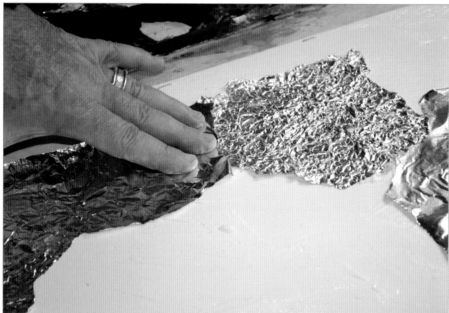

Step 2 Arrange irregular pieces of aluminum foil in a pleasing pattern on the board. Crinkle up some of the pieces, and keep others flat and smooth. The contrast between the wrinkled foil and the smooth foil creates visual interest. Leave select areas of the board's surface free of foil.

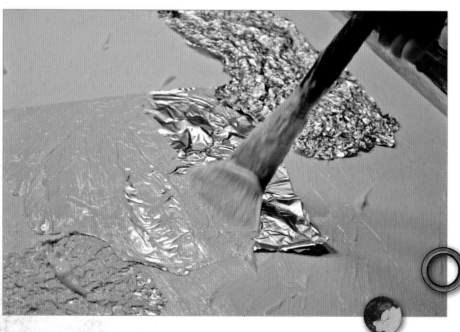

Step 3 Cover the foil surface with a thin layer of gel medium, and add a few more foil pieces on top of the first layer. Again, try to show a contrast between wrinkled pieces and smooth pieces, remembering to leave some areas of the board without foil.

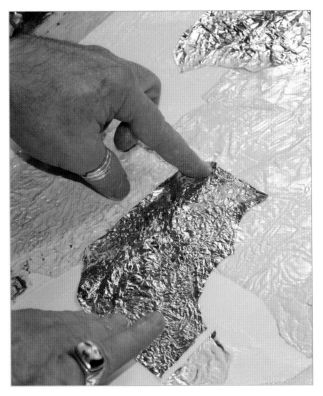

Step 4 Add a few pieces of gold or other metal-based foils for a slightly different color contrast and additional visual interest. This will be slightly noticeable in the finished piece.

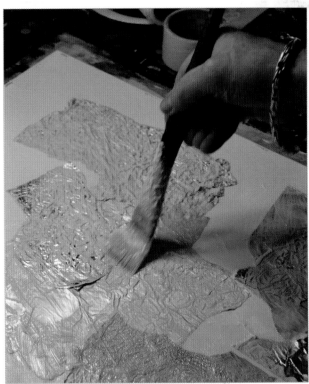

Step 5 Cover the entire surface with another layer of gloss gel medium, and allow it dry completely. The gel medium will dry clear.

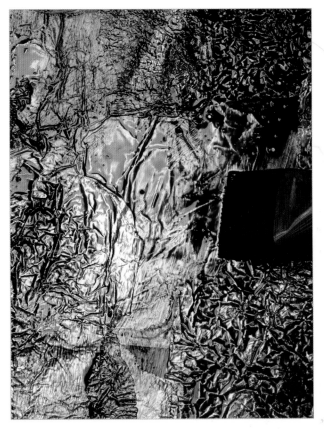

Step 6 Paint a wash of Prussian blue and phthalo blue over the entire surface. The blue paint should seep into all the cracks and crevices of the foil. Allow it to dry completely.

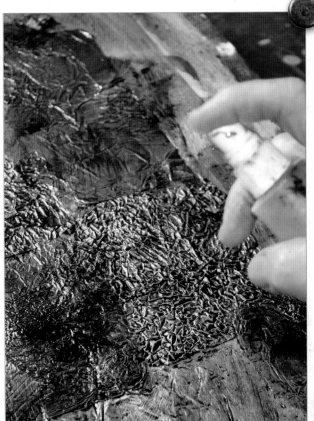

Step 7 Bring the shine back to the foil surface by spraying rubbing alcohol onto the dry paint and then blotting off some of the paint with a paper towel. This will leave remnants of paint in the cracks and folds of the foil. Allow it to dry.

Step 8 Using a sponge, apply alizarin crimson and nickel azo yellow to the entire surface of the painting in a random pattern; then blend the colors together with a paintbrush.

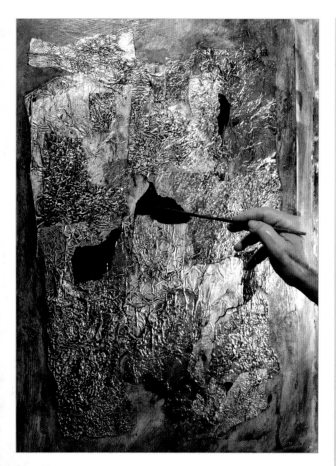

Step 9 Paint some of the foil-free areas with black. The addition of a dark opaque color will add interesting visual contrast.

Collecting Accent Materials

Continually think about textures and interesting accents you can add to a mixed-media piece while you are creating it. Texture can be physical—created with fibers; metal; paper; gesso; and found objects, such as coins, beads, and buttons. Or texture can be visual—created with paint and stamps. I keep several bags of paper, stamps, foils, and found objects in my studio when I paint, and I'm forever seeking out new and unique ways to create the visual excitement that's possible with mixed media.

Brass Foil Accents

Step 1 Cut out small brass-colored foil squares and rectangles.

Step 2 Create an interesting pattern of swirls and circles on the brass-colored shapes by pressing into the foil with an embossing tool or a ballpoint pen.

Step 3 Arrange the shapes in a pleasing pattern on the surface of the painting. They will serve as interesting points of focus. Always try to keep the viewers' eyes moving around the painting and not off to the edges.

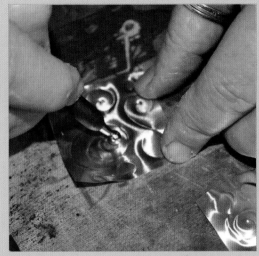

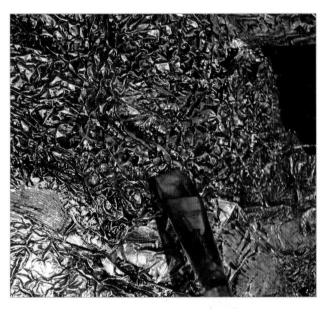

Step 10 Add a few highlights of phthalo blue mixed with titanium white.

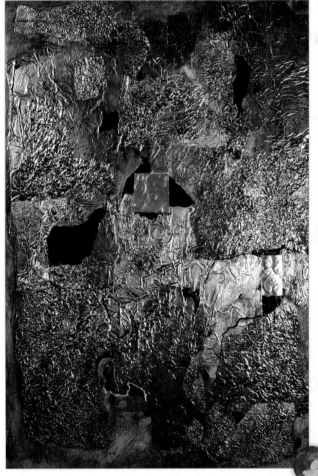

Step 12 Finally, add a coat of gloss varnish to seal the painting.

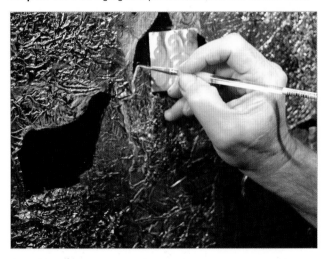

Step 11 Add a few brass-colored foil accents to the piece using acrylic gloss medium. (See "Brass Foil Accents," above.) Next add some fluid, metallic-acrylic paint highlights using a small brush. The color of the highlights should match or complement the brass shapes.

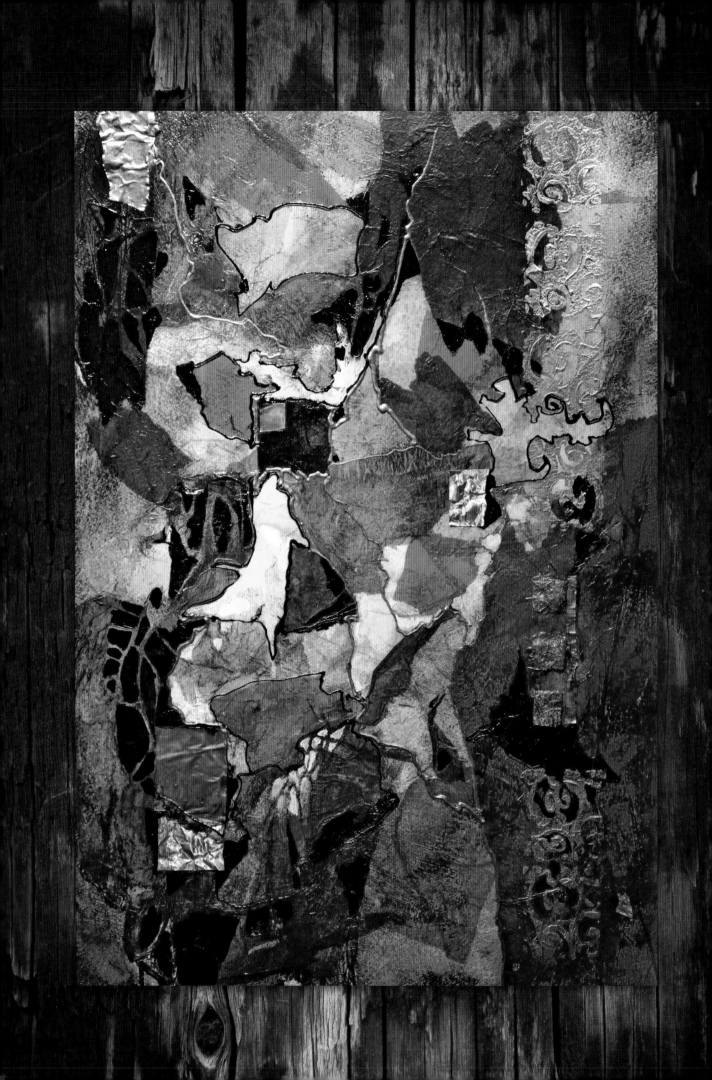

Tissue Paper & Handmade Stamps

Multiple layers of tissue paper provide a colorful background for accents of copper paint, foil, textured paper, and handmade stamps in this acrylic painting project.

Materials

- 300lb cold-pressed watercolor paper
- Acrylic gloss gel medium
- Acrylic paints: See "Joe's Palette," page 63
- Copper foil
- Embossing tool or ballpoint pen
- Gloss gel medium
- Low-density acrylic paints: metallic copper, shiny black
- Rubbing alcohol
- Sponge
- Squeeze bottle
- Styrofoam plate
- Textured paper
- Torn tissue papers in a variety of colors

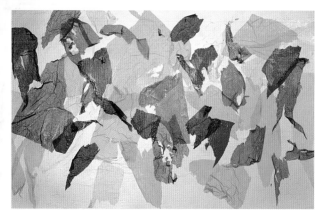

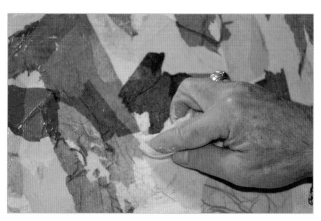

Step 1 Apply a thin coat of acrylic gloss gel medium to 300lb cold-pressed watercolor paper, and arrange the colored tissue papers in an interesting pattern. Cover the tissue paper with another layer of gloss medium, and allow it to dry.

Step 2 Next, paint over the tissue paper with yellow oxide and nickel azo yellow. While the paint is still wet, use a paper towel to rub some of it off, leaving a light coloring of yellow on the surface. Allow it to dry completely.

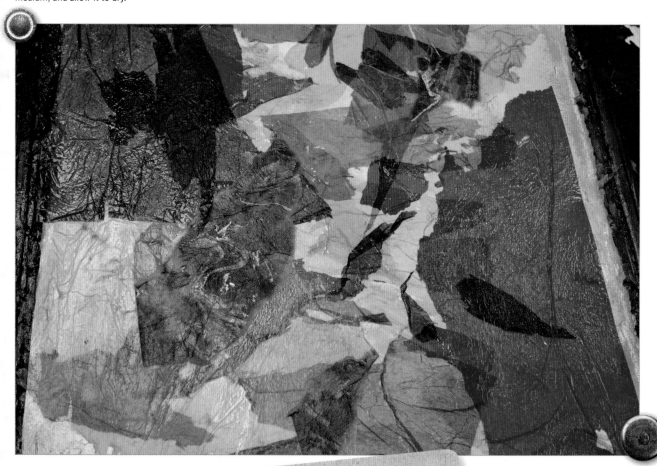

Step 3 Cover the surface with another layer of gloss gel medium, and add more layers of tissue paper until you've built up subtle depth to the painting. Allow it to dry completely.

Artist's Tip

Most of my paintings are abstract, which provides some unique perspectives and presents some challenges. As a painting progresses, I often rotate the piece I'm working on 90 degrees and view it from several angles. A successful abstract piece should maintain balance and a pleasing visual appearance in any orientation. Upon completion, however, deciding which way to hang the piece can present a bit of a challenge. For this reason I often sign my name at an angle in a corner, or forgo signing until the painting's owner decides how they will hang it.

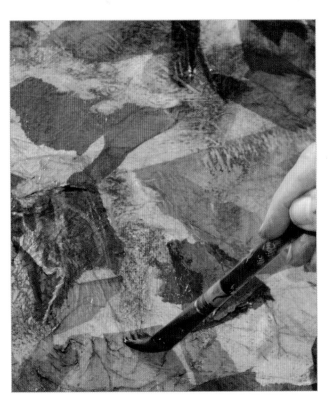

Step 4 Now cover the painting with washes of phthalo blue and alizarin crimson. Allow it to dry.

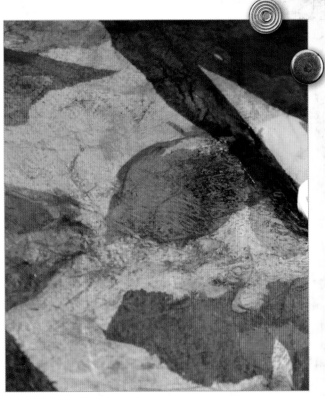

Step 5 Spray rubbing alcohol on the surface, and rub off some of the paint, allowing the yellow underpainting to show through while leaving traces of the blue and crimson paint on the surface.

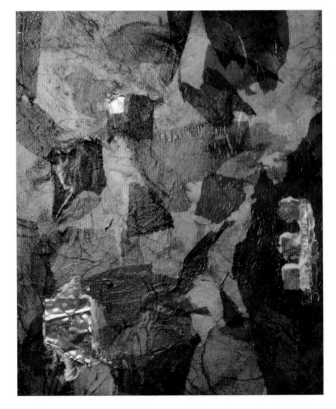

Step 6 Adhere a few irregular pieces of copper-colored foil and squares of textured paper to the painting with gloss gel medium. As you arrange these accents, think about how you will keep the viewers' eyes moving around the painting.

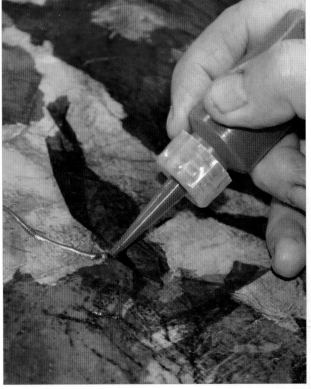

Step 7 Using a squeeze bottle and/or a thin paintbrush, outline some of the tissue paper and foil embellishments with low-density, metallic copper acrylic paint. Repeat with low-density, shiny black acrylic paint.

Making Stamps

Handmade stamps can be created easily using a variety of household items. They will add interesting and original visual texture to your piece.

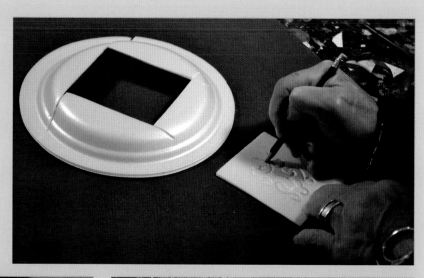

Step 1 Cut a square out of a Styrofoam plate.

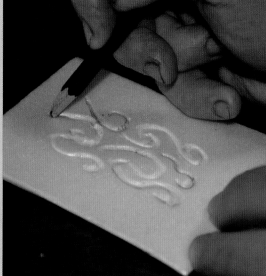

Step 2 Emboss a swirl pattern into the foam with a pencil to create the design you want your stamp to leave behind.

Step 3 Brush the design-side of the stamp with metallic copper paint, and then press it onto the surface of the painting.

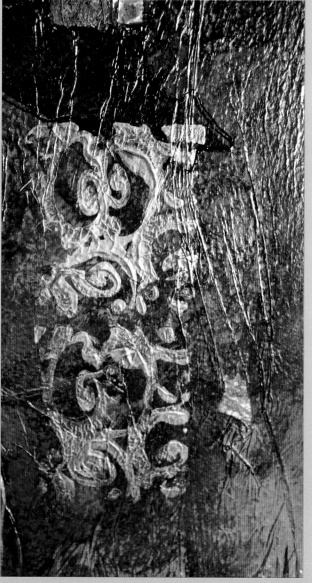

Step 4 The stamp creates an interesting visual texture on the painting.

Step 8 Use a small brush to add the finishing touches with yellow, Titan buff, and black.

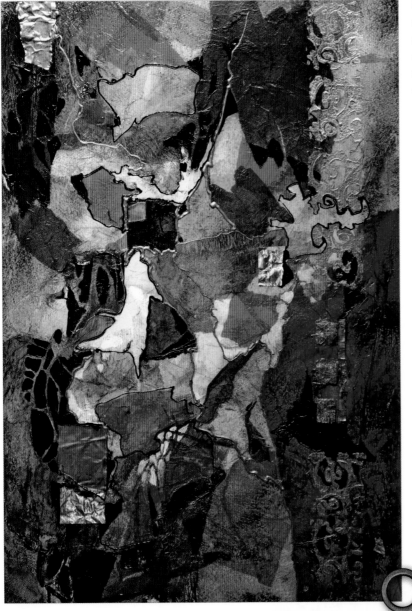

Step 9 Finally, add handmade stamps for additional visual interest. (See "Making Stamps," on opposite page.) Then seal the finished painting with acrylic polymer varnish or gel medium, keeping in mind that gel medium is thicker and will leave visible brushstrokes.

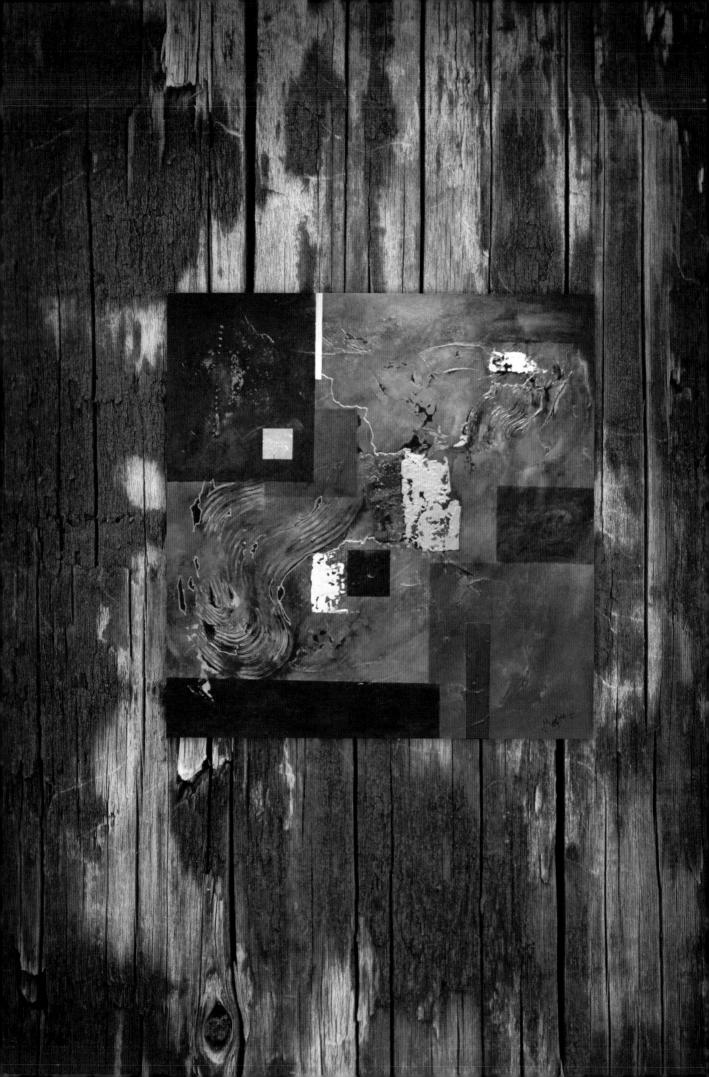

Geometric Shapes on Canvas

The texture of this project was created using heavy gesso and handmade paper on canvas. It starts with an interesting textured background, followed by layers of acrylic paint. Geometric shapes, which are created by masking off areas of the canvas during the painting process, offer interesting focal points.

Materials

- Canvas
- Acrylic gloss gel medium
- Acrylic paints: See "Joe's Palette," page 63
- Heavy gesso
- Heavy, textured paper
- Masking tape
- Palette knife
- Sponge
- Tooth-edged trowel

Step 1 Using a large palette knife, cover large areas of the canvas with a thick layer of heavy gesso. Create texture by pressing the palette knife into the gesso and then quickly pulling it off the surface.

Step 2 Use a tooth-edged trowel to create grooves in the wet gesso. Like the palette knife, the trowel can be pushed into the gesso and then pulled off quickly to create an interesting texture. Make sure the grooves and the textures create an interesting visual appeal and keep the viewers' eyes moving around the canvas and not to the edges of the painting.

Step 3 Next, push pieces of heavy-textured paper into the wet gesso, ensuring that the paper creates an interesting and appealing effect. Let the painting dry overnight.

Step 4 Add a layer of acrylic gloss gel medium to the surface, and allow it to dry completely. Then add washes of warm acrylic paint to the surface using cadmium yellow, yellow ochre, raw sienna, and nickel azo yellow. Make sure the colors get into the grooves and indented surfaces of the painting. Allow this to dry completely, and then cover the surface with another layer of gel medium. Again, allow it to dry completely. To the yellow surface, add burnt umber and alizarin crimson. Allow some of the yellow to show through by applying the darker paint to raised surfaces only.

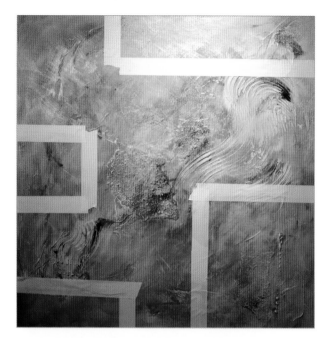

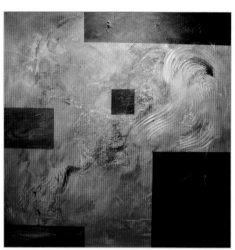

Step 5 Once dry, cover the surface with another layer of gel medium. Allow it to dry completely. Tape off some rectangular and square areas with masking tape. Then paint in the shapes with dark colors, including Payne's gray and raw umber.

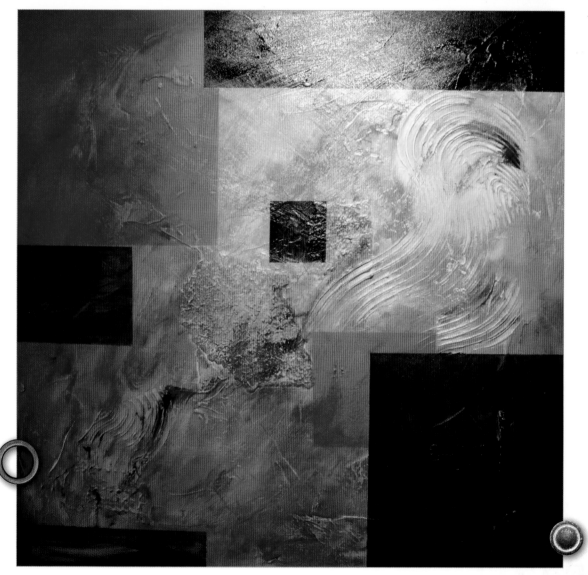

Step 6 Add more rectangular shapes, painting them cadmium red and cadmium orange. Cover the piece with another layer of gel medium, and allow it to dry completely.

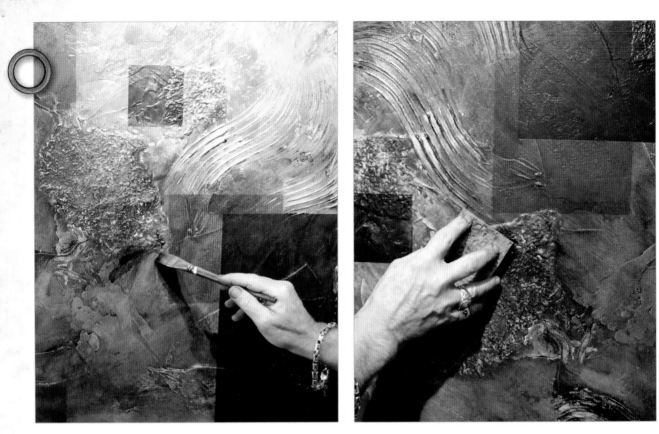

Step 7 Apply a mixture of raw umber and black to the surface of the painting with a paintbrush. While still wet, use a sponge to lightly wipe off the excess paint. Allow the piece to dry completely.

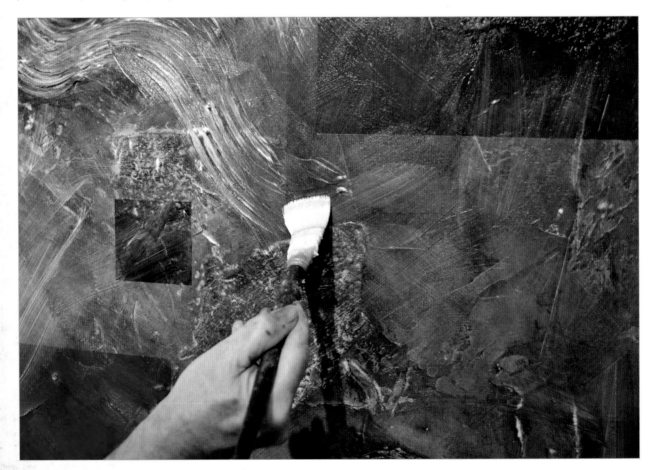

Step 8 Add another layer of gel medium, and allow it to dry.

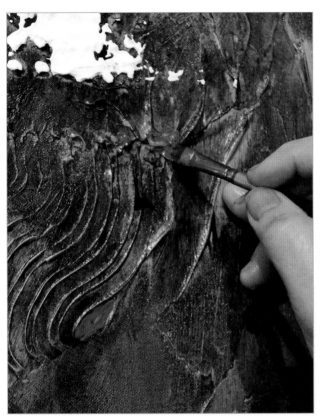

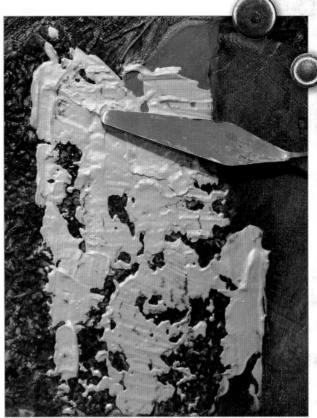

Step 9 Accent the piece by adding titanium white with a small palette knife. Next, using a small brush, add accents of phthalo blue mixed with white.

Step 10 Add highlights of bright gold with a palette knife.

Step 11 When dry, attach hanging hardware to the back of the canvas so that you can display your geometric work of art.

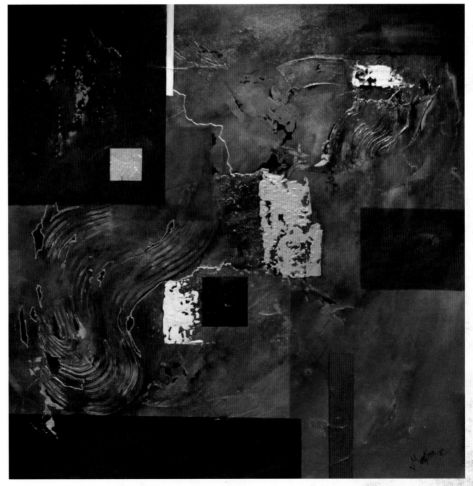

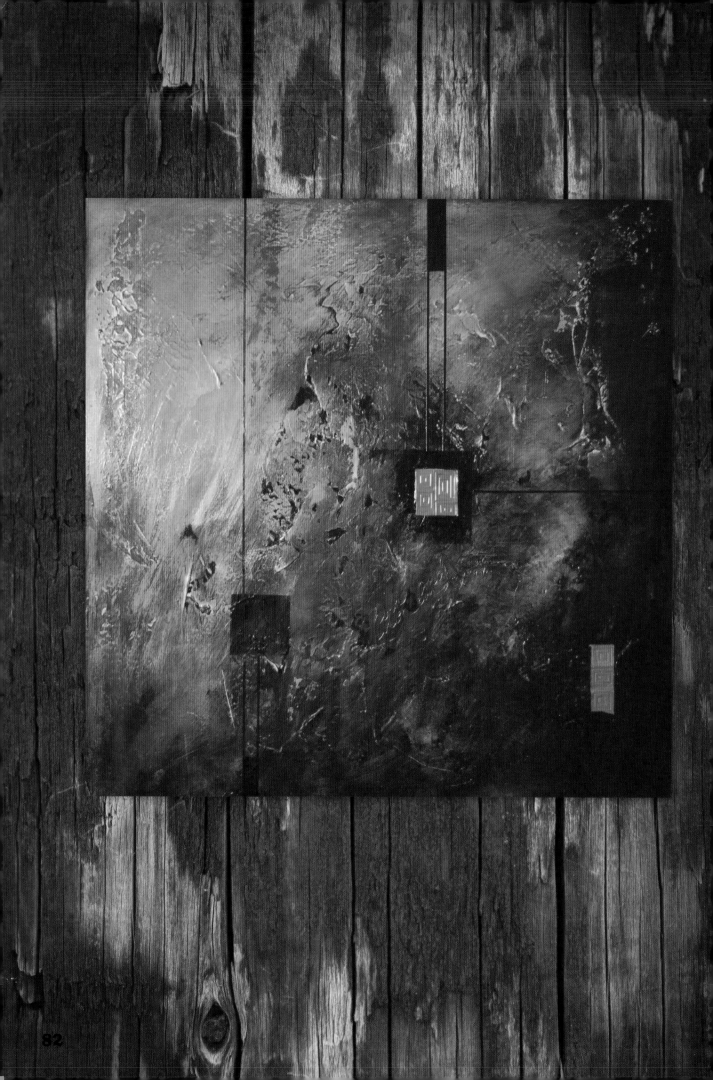

Heavy Gesso & Embossed Foil

This painting consists of heavy gesso on canvas. A "hidden message" embossed into the wet gesso is barely visible on the surface of the final painting. An embossing machine produced some textured foil accents, while black artist tape was used to section off the surface into interesting shapes.

Materials

- 1/8-inch wide, glossy, black artist tape
- 38-gauge, red, aluminum embossing foil
- Acrylic gloss gel medium
- Acrylic paints: See "Joe's Palette," page 63
- Canvas
- Embossing machine or ballpoint pen
- Heavy gesso
- Low-density acrylic paint: shiny black
- Masking tape
- Sponge

Step 1 Use a palette knife to cover the surface of the canvas with a thick layer of heavy gesso.

Step 2 With the pointed end of a small brush, carve a "message" into the wet gesso. The message carved into this painting, "color and texture… color and gesture," represents my abstract expressionist viewpoint. It will be only partially visible once the painting is complete, but it will generate some interest and mystery. Make your message as cryptic or as fun as you desire. Allow the gesso to dry overnight, and then cover it with a layer of gloss gel medium. Allow the gel medium to dry completely.

Step 3 With a sponge, add a mixture of cadmium yellow, raw sienna, burnt sienna, nickel azo yellow, and green gold. Blend the paint well, ensuring that the entire surface is covered with color. Use a brush to work the paint into the creases of the gesso surface. When the paint is dry, cover the surface with another layer of gloss gel medium, and allow it to dry.

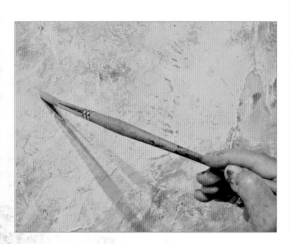

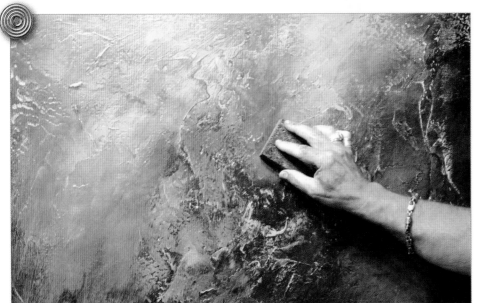

Step 4 Use a sponge to add combinations of cadmium red, cadmium orange, quinacridone magenta, and alizarin crimson to the top left of the canvas; then add phthalo blue, phthalo green, Prussian blue, and Payne's gray to the bottom right of the canvas. Blend the colors together. The sponge can be loaded with one or two colors and then quickly blended on the surface. Allow some of the yellow underpainting to show through.

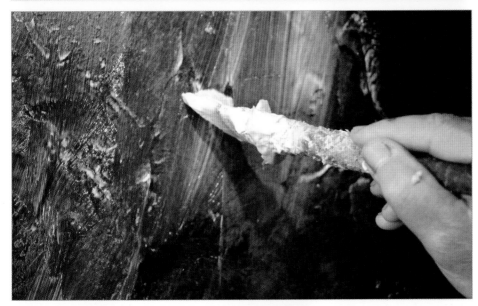

Step 5 Once the paint is dry, cover the entire surface with another layer of gloss gel medium, allowing it to dry completely.

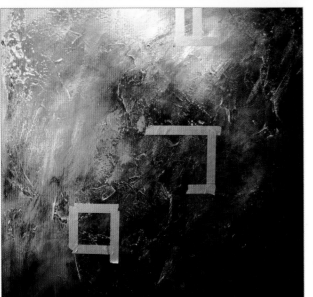

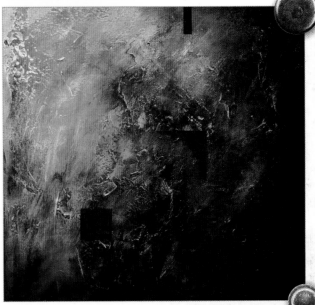

Step 6 Tape off a few select areas to create some hard-edged geometric shapes. Paint these areas with black, Payne's gray, and Prussian blue.

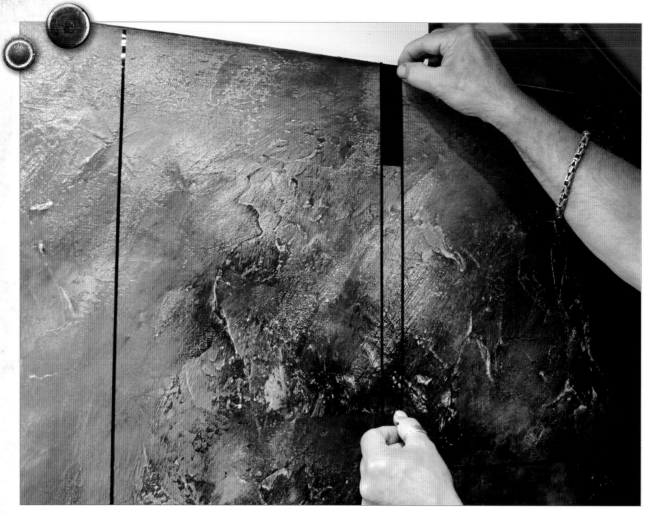

Step 7 Use ⅛-inch, glossy, black artist tape to create interesting rectangular or square areas.

Step 8 Next emboss some pieces of 38-gauge, red, aluminum embossing foil with an embossing machine or with a ballpoint pen. (See detail inset below.) Attach the foil pieces with gel medium where desired. Allow the gel medium to dry, and then paint another layer of gel medium over the tape and foil.

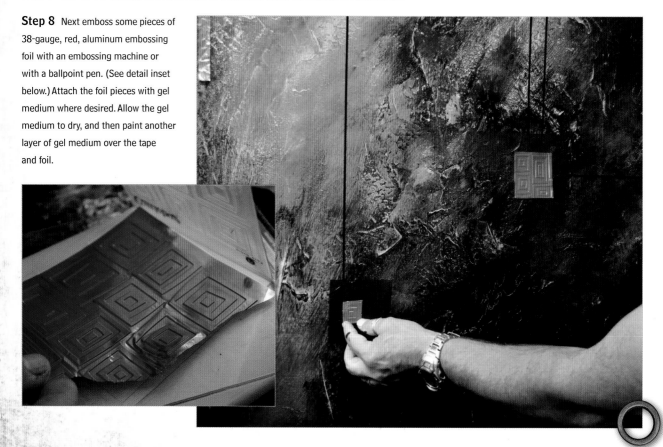

Step 9 Add accents of teal, alizarin crimson, and cadmium red with a small palette knife.

Step 10 Add a few interesting accents with shiny, black fluid acrylic paint. These black accents, in addition to the colored accents from step 9, will not only move the viewers' eyes around the painting but also create an interesting visual texture.

Step 11 Attach hanging hardware to the back of the canvas, and your painting is complete.

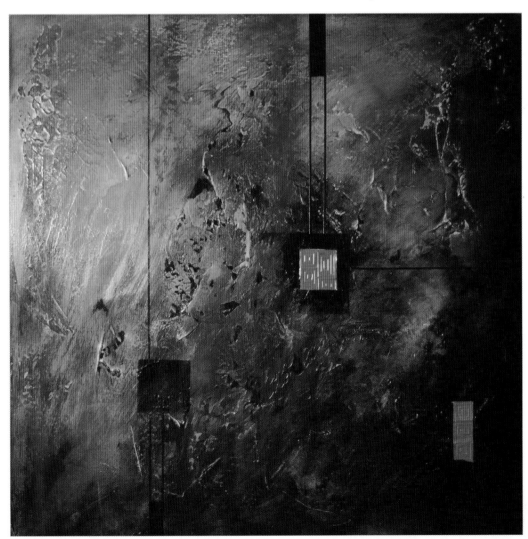

Stencils &
Spray Paint
with Mark Mendez

Mark Mendez spent his early childhood in
Southern California, where he played sports, collected
baseball cards, and doodled on scrap paper. While he
always had a well-exercised imagination, it wasn't
until he moved to Oregon in junior high school that
he began focusing on his creative skills. It was in this
new state, without his friends or the California sun,
that Mark began what he calls his "Bob Ross Era."
Bob Ross was an artist who hosted an oil-painting
program on the public broadcasting channel, and Mark watched religiously.
He soon enrolled in an oil-painting class at a local craft store.

In high school, Mark's exploration into the world of art found its wings. It was while watching an
animated commercial created by artist Geoff McFetridge that Mark realized he could earn a living
creating art. After high school, Mark moved back to California where he found his focus in graphic
design. Working with the digital medium intrigued him, but his love has always been the physical act of
pressing a pen, brush, or pencil to paper, canvas, or anything else that would take his mark. His induction
into the world of mixed media and stencils was influenced by the famous street artist Banksy and by
contemporary artist and illustrator Shepard Fairy. Mark has always wanted to be a street artist. He
admits that some of his art may have been shown on walls outside legal boundaries, but to him, the risk
outweighed the personal gratification. Today, however, Mark exhibits on gallery walls.

Inside the Artist's Studio

My inspiration comes from everything, and while that may sound cliché, it's the truth. But I don't act on every inspiration that comes to mind. Finding inspiration is easy, but finding a way to put your heart into a work is an equally important part of the artistic process. You may create a work of cool-looking art, but what does it mean to you? To me, art is ripping out a chunk of yourself and sharing it with those who are willing to look at it. I keep that in mind when approaching an idea for a new piece. I also consider the intended purpose of a piece before beginning. Selling a piece of art to someone who enjoys my work is an amazing feeling. But it's even better when I am able to create a connection between a client's vision and my own. The art is not simply hanging on the wall of their home or office—it's what they'll see before they go to bed and when they're leaving for work; it's what their guests will see. These thoughts can overwhelm me when I approach an idea.

Finally, I decide which medium fits the concept of a piece and what style will portray the idea optimally. I primarily use wood as my canvas. Wood is an amazing design of nature—each line of grain can add definition to a work. Found wood is even better because it provides an opportunity to re-purpose something that would have been thrown away and craft it into an extension of myself or something I can share with others. Once the different aspects of an idea become cohesive, I grab my pencil and begin. I don't stop until the piece is finished. When I interrupt my artistic process, new ideas cloud my mind, causing me to lose my original vision. There is such a thing as too much, so it's important to remember when to stop.

Thank you to my wonderfully supportive parents Dan & Lydia. Thank you to the beautiful person who brings me sanity, my wife Jickie.

—Mark Mendez

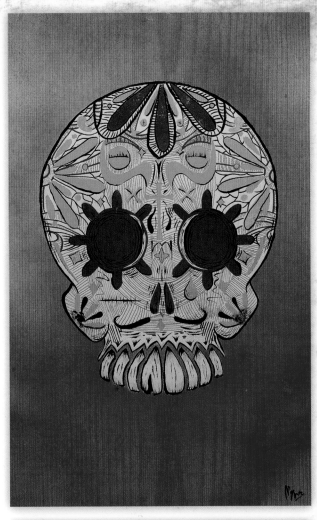

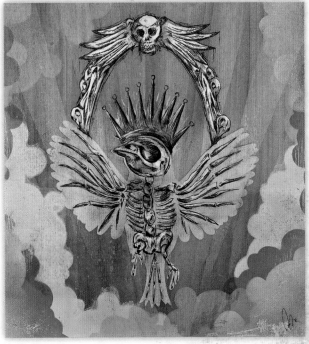

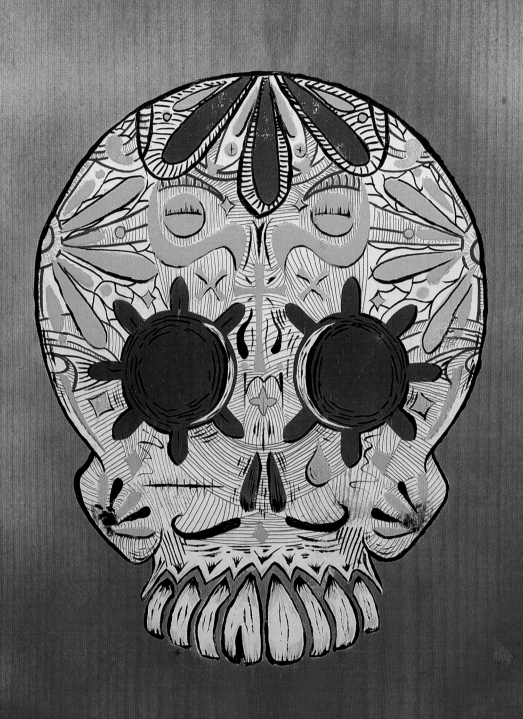

Dia de los Muertos Skull

Dia de los Muertos (Day of the Dead) is a Mexican holiday dedicated to the memory and honor of the deceased. Elaborate altars honoring late loved ones are adorned with many items, including colorfully decorated sugar skulls. Decorating a skull is a wonderful way to explore multiple levels of creativity. This mixed-media project combines stenciled graphics, spray paint, acrylic paint, and permanent markers on a fir plank to create a unique celebratory work of art. Fir is a soft wood with a pleasing grain pattern. It has a tendency to yellow, but it holds paint well.

In the tradition of Dia de los Muertos, this skull is dedicated to my great-grandmother, Mary Gomez.

Materials

- Adobe® Illustrator®, copy machine, or lightbox
- Artist tape
- Black acrylic paint
- Copy paper
- Multipurpose, acid-free adhesive
- Permanent markers (various colors)
- Spray paint (various colors)
- Swivel blade
- Wood panel

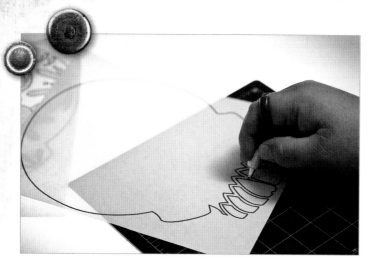

Step 1 Create a graphic from which all of your stencils will be based. I find it's easiest to draw circles and specific shapes using a computer program like Adobe® Illustrator®, but if you decide to draw by hand, use a lightbox to trace the shape of each stencil on a piece of standard copy paper. Note that each individual stencil should have its own color. For example, this skull's eye sockets, teeth, and decorative markings are all painted in different colors. If you create your graphic on a computer, print one copy of the graphic for each color paint that you intend to use. Keep in mind that every stencil needs to line up with the base graphic; it's also important that the graphics are solid shapes with no intersecting lines.

Step 2 Cut out the base graphic (skull outline) using a sharp blade. Swivel blades work best and feel similar to drawing with pen. Save the negative pieces cut from the stencils.

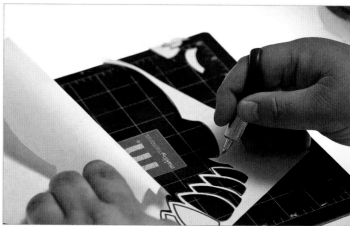

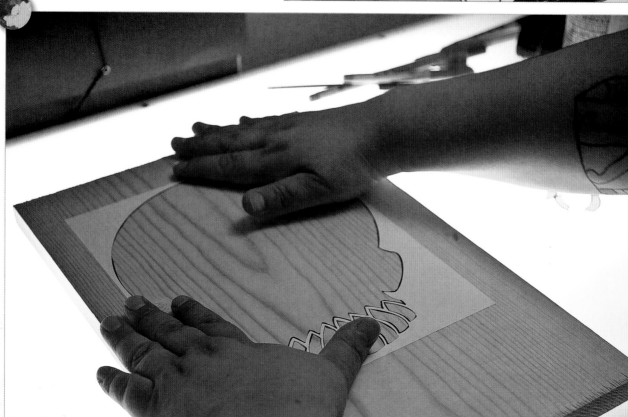

Step 3 Next, set up your work station in a well-ventilated area. As an additional precaution, you may want to cover your nose and mouth with a mask to avoid inhaling paint dust. Spray the back of the stencil with a light, even coat of multipurpose acid-free adhesive. (Too much adhesive will permanently glue the stencil to the wood.) Find the best placement for the skull on the wood plank, position it, and lightly smooth out the edges.

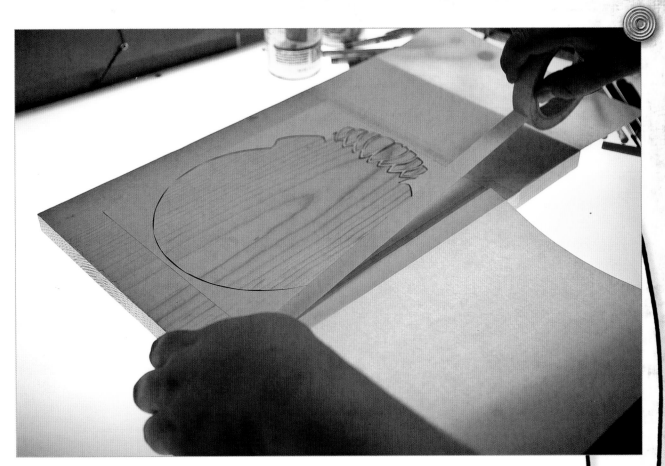

Step 4 Use light-duty artist tape and paper scraps to mask off the areas of the plank you want to keep free of paint.

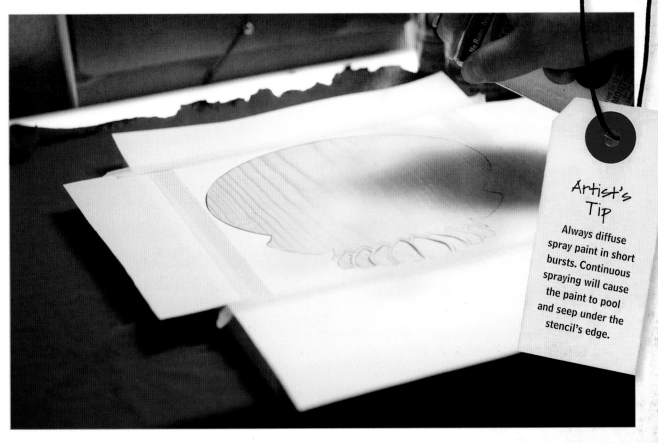

Artist's Tip

Always diffuse spray paint in short bursts. Continuous spraying will cause the paint to pool and seep under the stencil's edge.

Step 5 Select a light color of spray paint for the first stencil base, as dark colors will impede on later design elements. Apply paint in a sweeping motion across the stencil, releasing it each time you complete a movement from one side to the other.

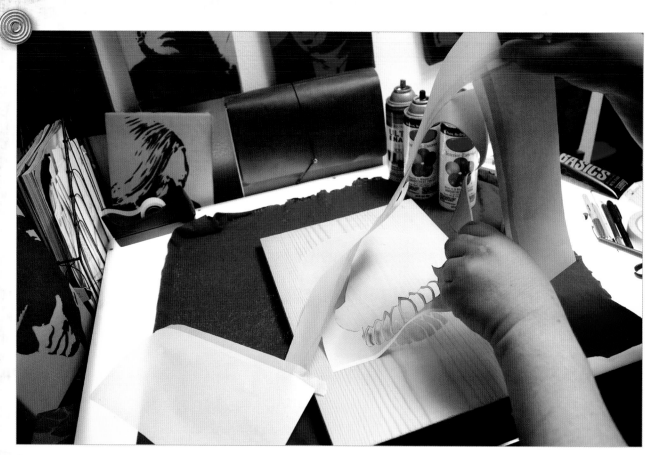

Step 6 While the paint is still slightly wet, carefully remove the stencil and masking from the plank. Don't wait too long—spray paint dries quickly! Use a blade to lightly separate the stencil from the wood if necessary. Put your stencils in a safe place so you can reuse them.

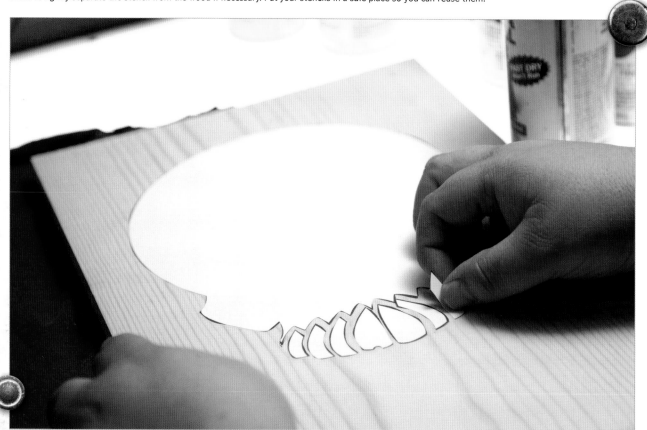

Step 7 When the paint has dried, lightly spray the backs of the negative pieces that were cut from the stencil in step 1 with adhesive. Then place them on top of the painted skull shape to protect it from the next layer of paint.

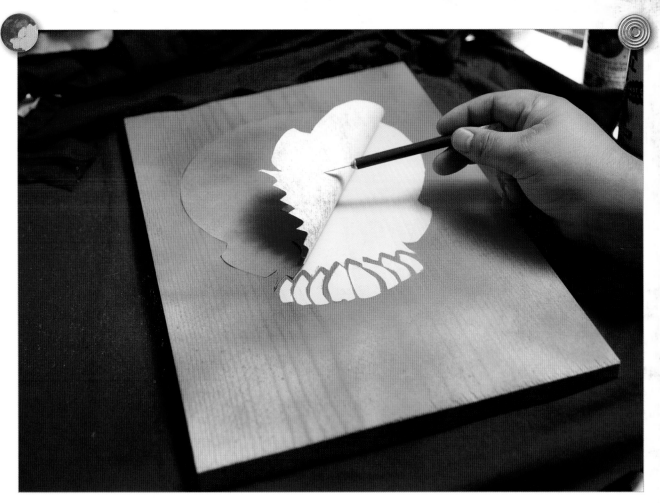

Step 8 Once the paper has set, lightly spray a darker or brighter shade of paint onto surrounding wood. You may wonder why I didn't spray the darker color first and then overlay the stencil. The reason is that paint colors can react to each other in unexpected ways, so it's better to separate them to maintain the desired effect. When you are finished spraying the wood, use a blade to gently lift and remove each individual stencil. The paint will be slightly wet, so use caution.

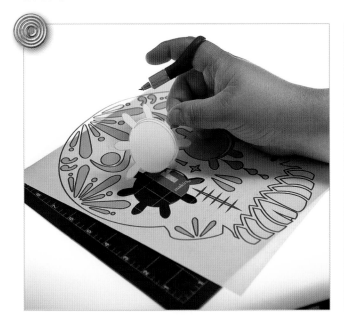

Step 9 Now it's time to embellish the base design. First, use a swivel blade to cut your first set of decorative stencils from the skull graphic. In this example, I cut out the eyes, nose, and three decorative elements at the top of the head.

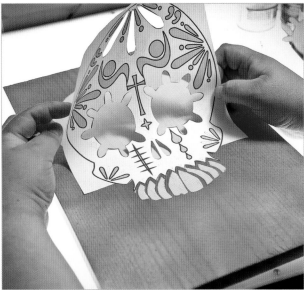

Step 10 Next, cut along an outer-edge of the stencil (I cut along the teeth) to create a guide that you can use to line up the stencil with the painted skull. Lightly spray the backside of this stencil with adhesive, line it up with the painted skull, and set in place.

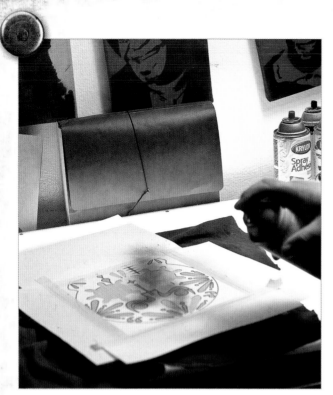
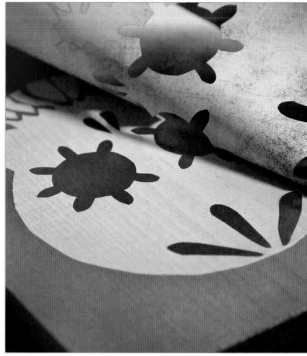

Step 11 Referencing the previous steps, mask off the stencil to protect the areas of the plank that you do not want to paint, and spray a different (preferably darker) color to fill in the stencils. Remove the stencil carefully while the paint is still tacky.

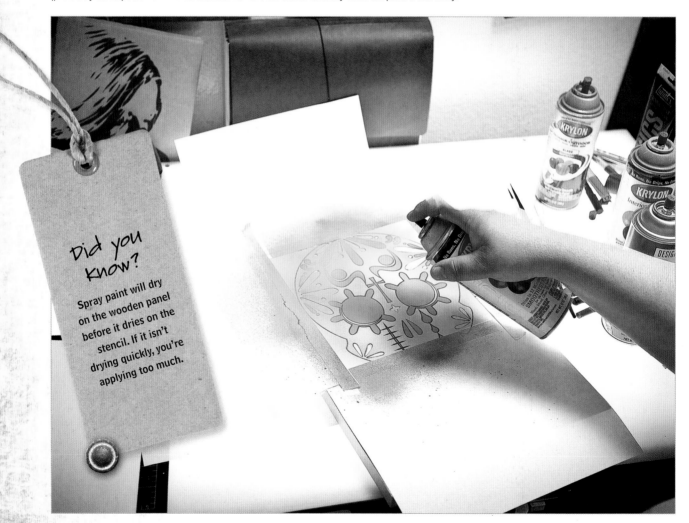

Did you know?

Spray paint will dry on the wooden panel before it dries on the stencil. If it isn't drying quickly, you're applying too much.

Step 12 Repeat these steps with the rest of your stencils and different colors of spray paint until the design on the skull is complete.

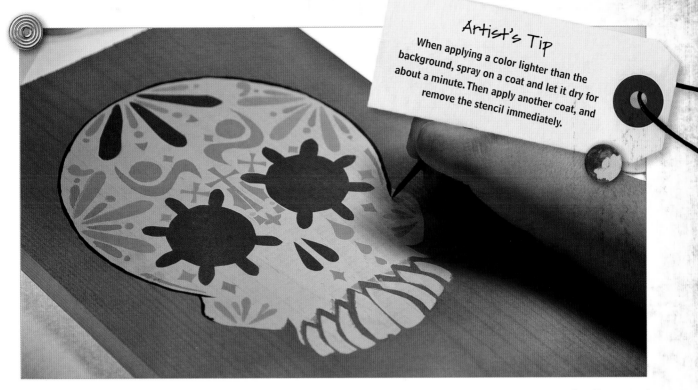

Step 13 When the stencil on the wood plank is complete, outline the skull and add more design elements with a semi-fine brush, first dipped in water, then in black acrylic paint. This process will give the paint the viscosity of ink.

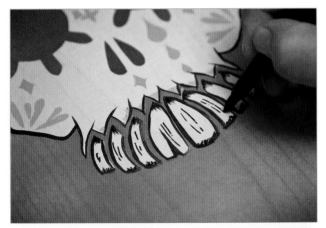

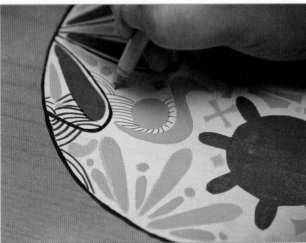

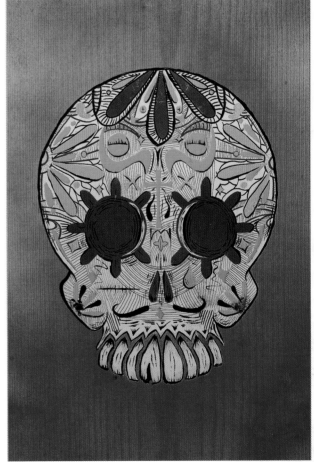

Step 14 Use permanent markers to create fine lines and intricate designs, as well as to add intersecting lines, details, and other elements you feel the piece should have.

Step 15 Attach hanging hardware to the back of the wood plank.

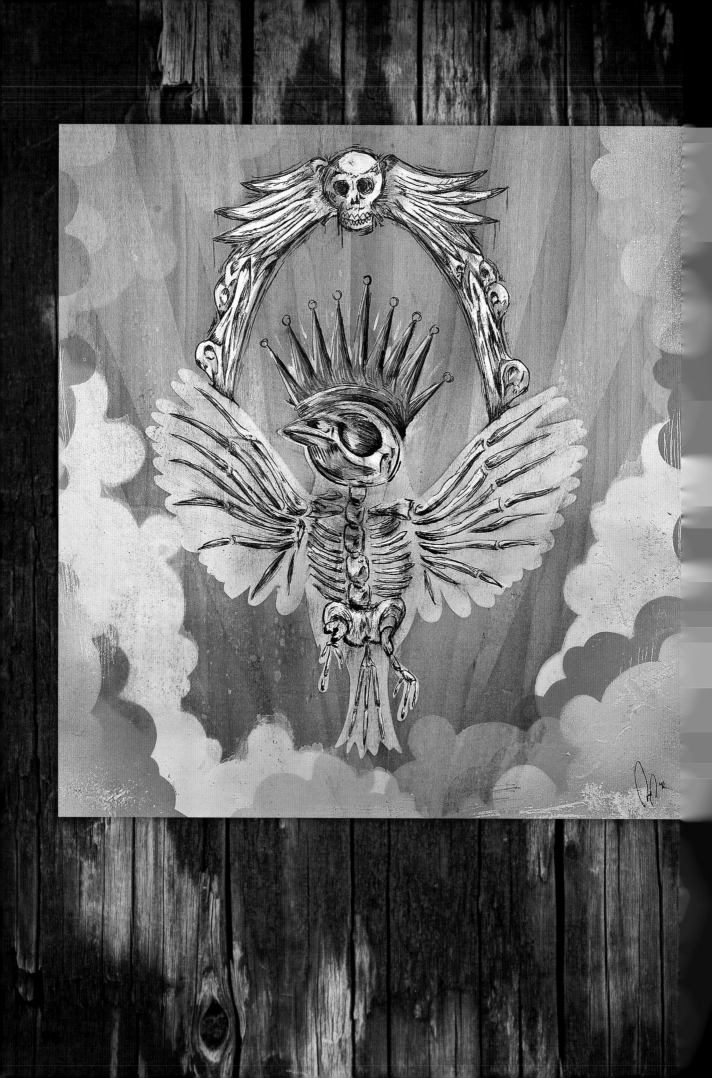

Bird Among Clouds

Living in Southern California, I truly appreciate the way clouds and sunsets influence my art. I often enjoy gazing at clouds and looking for shapes and characters hidden within them. In this piece, sunlight bursting through clouds contrasts with a much darker image, yet the piece still conveys bright and positive emotion.

Materials

- Adobe® Illustrator®, copy machine, or lightbox
- Artist tape
- Fine-tip indelible pen
- Multipurpose, acid-free adhesive
- Square plank of wood
- Copy paper
- Acrylic paints: white, black
- Spray paint (various colors)
- Swivel blade or utility knife

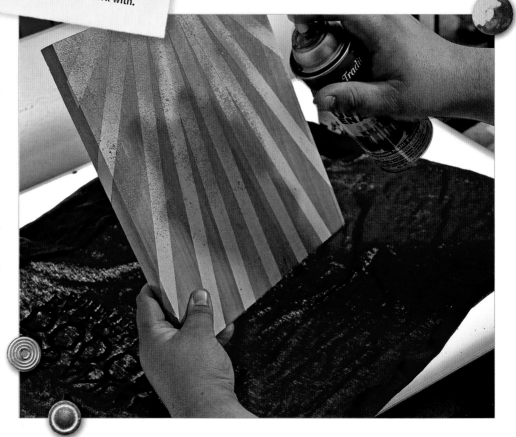

Artist's Tip

I used a poplar plank for this project, which is challenging to work with, as paint has a tendency to pool on its surface. Beginning artists may find fir and birch easier to work with.

Step 1 Set up your station in a well-ventilated area. As an additional precaution, you may want to cover your nose and mouth with a mask to avoid inhaling paint dust. On a square plank of wood, lay down strips of artist tape that fan out like sun rays.

Step 2 When the tape strips are in place, apply an opaque layer of yellow spray paint to the surface, using an even sweeping motion. Allow it to dry for a few minutes; then carefully spray a light mist of orange or red over the lower half of the plank where the tape strips are closer together, making the application thicker at the bottom and lighter in the middle to create a faded effect. Carefully remove the tape when dry.

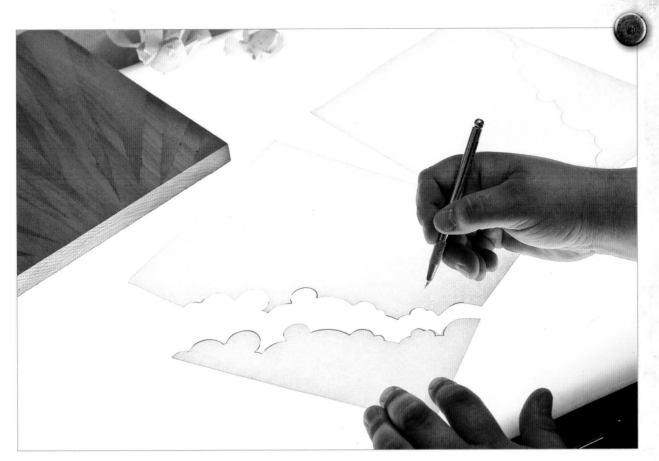

Step 3 Draw cloud designs along the corners of two pieces of standard copy paper; then use a swivel blade or utility knife to cut around them. Next, turn the pages away from each other so that both stenciled edges are facing outward. Use a bit of adhesive to join the pages together in the center, creating one single stencil.

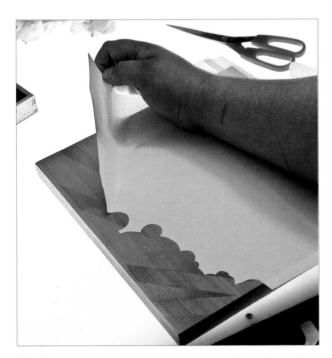

Step 4 Spray the backside of the stencil with a very light, even coat of multipurpose acid-free adhesive. Then position it in the center of the plank, with the cloud designs facing the edges of the plank and exposing the corners of the sun rays.

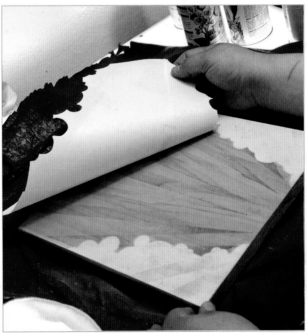

Step 5 Spray a thick layer of light-colored spray paint, such as white or light blue, in a sweeping motion across the exposed areas of the plank. While the paint is still slightly wet, peel off the stencil.

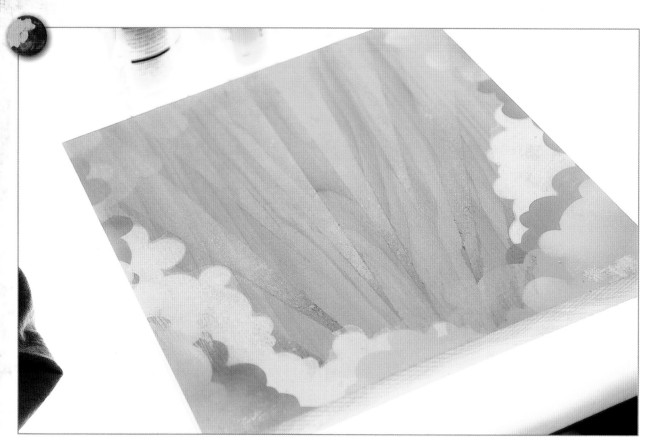

Step 6 Allow the first layer of paint to dry until slightly tacky to the touch; then slightly reposition the stencil (do not reapply adhesive) in a slightly different area on the plank. Mask off the areas that you want to keep paint free; then repeat the process. Continue this process, applying light colors to create layers of clouds.

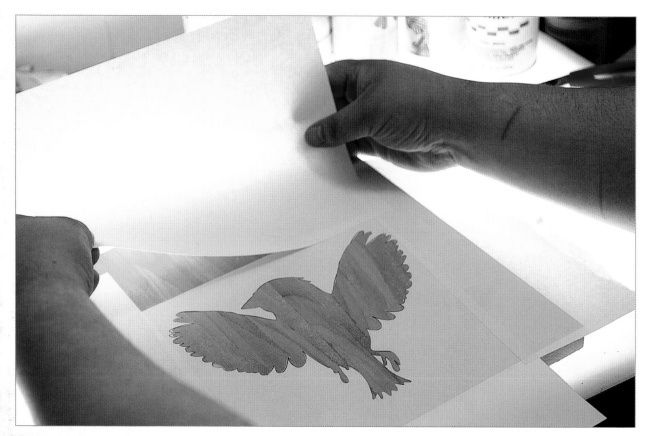

Step 7 Draw a stencil shaped like a bird with outstretched wings. Cut out the bird shape and set aside. Spray the back of the stencil with adhesive, and position it on the wooden plank.

Step 8 Mask the outer areas; then spray over the stencil with one of the light colors you used to create the clouds. Remove the stencil carefully and allow the paint to dry.

Step 9 Spray the back of the bird shape cut from the stencil with adhesive, and place it on top of the painted bird on the plank.

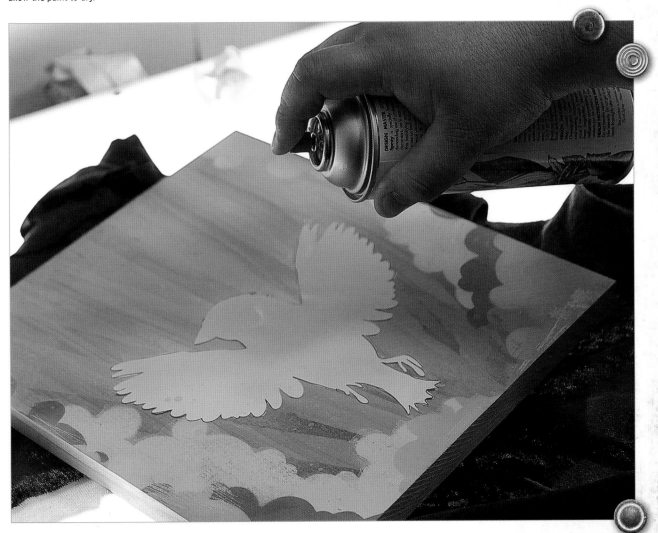

Step 10 Spray paint a light color, such as white or yellow, around the figure to create a halo effect. Allow the paint to dry until tacky, and then carefully peel off the paper.

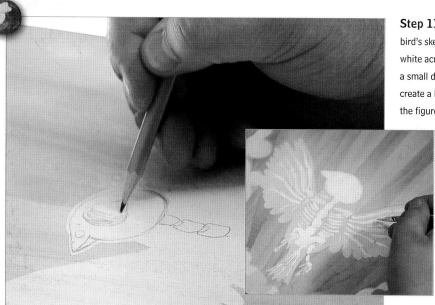

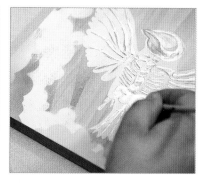

Step 11 Once the paint is dry, draw an outline of the bird's skeleton with a pencil. Then fill in the skeleton with white acrylic paint and a thin brush. To add shading, mix a small dab of black acrylic paint with the white paint to create a light gray color. Apply it to select areas to give the figure depth.

Step 12 With a fine-tip pen, outline the skeleton with bold lines. Feel free to add more shading with some light crosshatching.

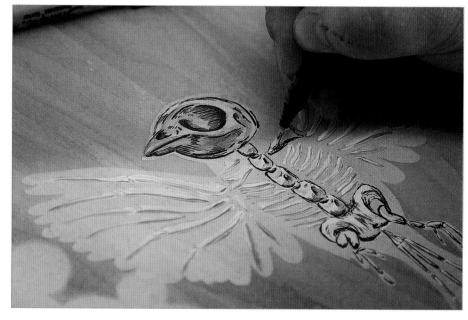

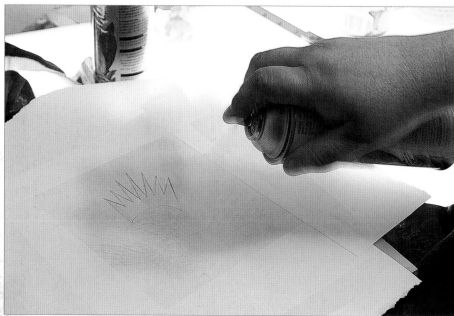

Step 13 I decided to add a crown to the bird's head, so I followed the previous steps to create a stencil, mask the areas of the plank, and spray paint the embellishment above the bird's head.

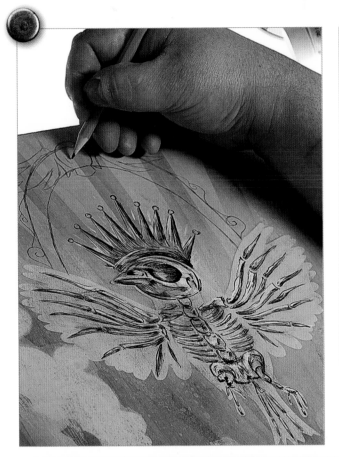

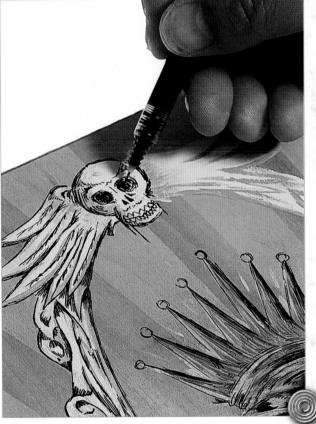

Step 14 To tie the piece together, decorate the crown and add a decorative arch using the same techniques you used to create the skeleton inside the bird.

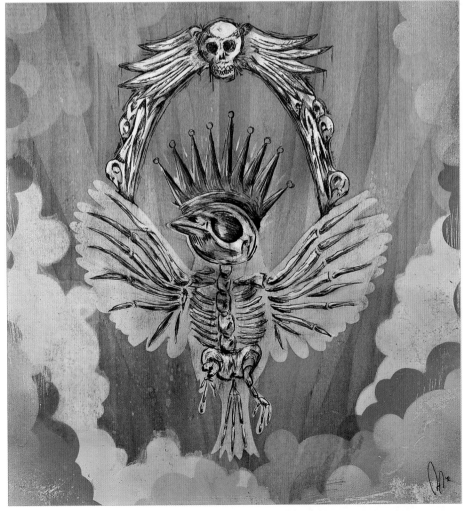

Step 15 Your painting is now complete. Attach some hanging hardware to the backside so that you can display your work.

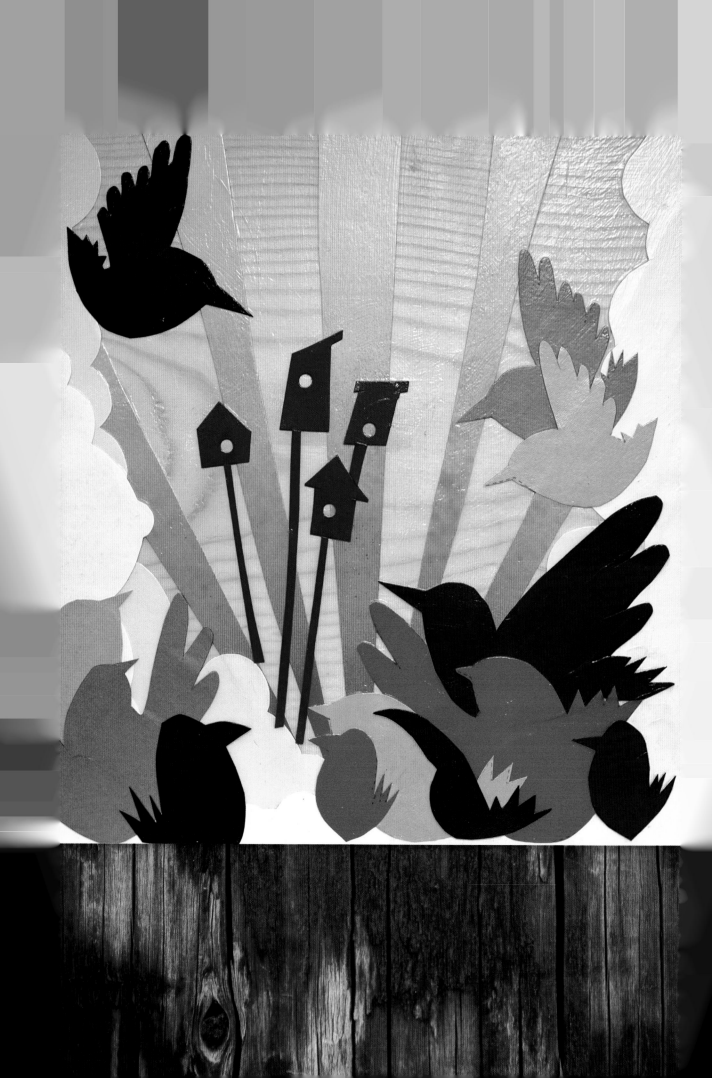

Recycling Stencils

For this project, I will demonstrate how artists of all skill levels can create beautiful mixed-media pieces with a few simple materials. This colorful bird collage was created with decoupage medium, stock paper, and a wood plank. The unused papers in this project can be used as stencils for other projects later, so save your scraps and cut carefully!

Materials

- Adobe® Illustrator® (optional)
- Artist's blade
- Decoupage glue
- Wood plank
- Hole punch
- Plastic cup
- Stock paper in a variety of colors
- Spray paints: orange, red, yellow

Step 1 Begin by creating multiple bird outlines in Adobe® Illustrator® and printing them out on multicolored stock paper. You can also draw the bird outlines directly on the stock paper. Organize your templates by color. Next, cut out each bird shape, considering the colors, shapes, and composition of the final piece. Once the selection of birds has been made, set them aside.

Step 2 Now either draw or digitally create a variety of cloud shapes around the perimeter of one or two different colors of stock paper that are the same size as the wood plank. Cut around the shapes, preserving the perimeter pieces. Align the perimeter pieces on the wood plank to get a sense of where to place them and to ensure they are sized properly.

Step 3 Mist a combination of red, yellow, and orange spray paints on a piece of white cardstock, fading the colors into each other to create a sunset-like effect.

Step 4 When the paint is dry, cut the paper into vertical strips; then cut the vertical strips diagonally to create long triangle sunbeams.

Step 5 With a medium-broad paintbrush, coat the backside of the sunbeams with the glue. Position them in a fan-like pattern, with the pointed ends meeting in the center of the bottom of the plank. When the sunbeams are in position, liberally decoupage over the wood plank and paper strips with the glue mixture.

Step 6 Apply the decoupage mixture to the backs of the cloud cutouts, place them over the sunbeams, and then liberally cover the surface with additional decoupage. While the glue appears opaque, it dries clear. The more glue that is applied, the easier it is to move and manipulate the stock paper shapes after they have been placed on the wooden plank.

Step 7 Begin to arrange the paper bird shapes on the wood plank. Coat the backsides with the decoupage glue, place them in position, and then paint over them with additional decoupage medium. Apply the decoupage liberally so that the birds can be shifted and moved until you are pleased with the composition.

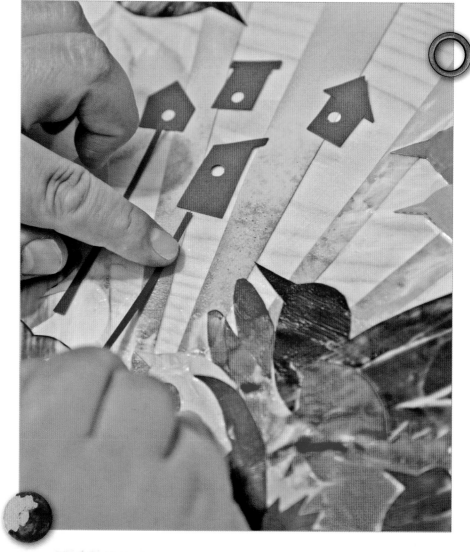

Step 8 Now create birdhouses and stands from a sheet of stock paper, making them small so that they appear to be in the distance when you apply them. Use a small hole puncher to create tiny entrances. Once the birdhouses are in position, coat them and the entire piece with a final layer of the decoupage. Let the piece dry thoroughly in a well-ventilated area.

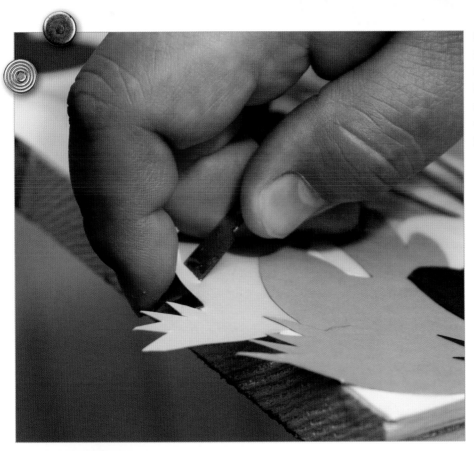

Step 9 When the piece is completely dry, use an artist's blade to trim the paper around the edges of the wood plank.

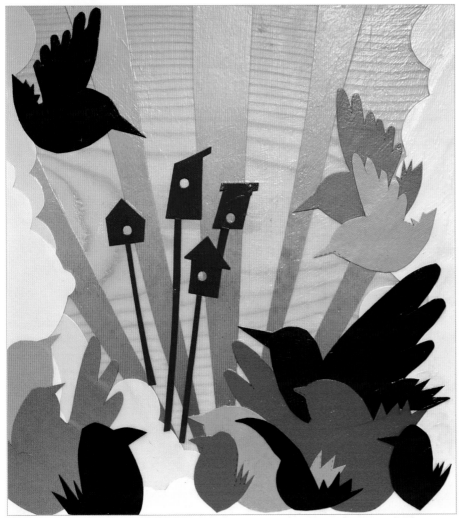

Step 10 Attach hanging hardware to the back so you can display your work.

Found Poetry

with Bette McIntire

Bette is a self-taught artist who works out of a sense of necessity—or what she calls a "restless inner impulse." Bette began making her Daily News collages one day when the idea came to her to show her philosophy in artwork. She looked for a poem in that day's newspaper; then she looked through her husband's studio for brushes, paints, pencils, pens, and glue. She went to work and her Daily News collages were born, showing that we can re-imagine any random day by creating art out of what we have at hand.

Bette earned a BA in English from University of California, Los Angeles, and an MA in philosophy of religion from Claremont Graduate University. She has worked as a writer for most of her life. Her spontaneous leap into visual arts may be attributed in part to her many trips to galleries and museums with her husband, Glenn, an artist himself. All the artwork she viewed over the years seems to have seeped into her consciousness. She exhibits her Daily News collages annually at the Sawdust Art Festival in Laguna Beach, California. Visit www.hoboworks.com.

Inside the Artist's Studio

A hidden poem stirs within the black and white "who, where, what, when, and how" of each day's newspaper. I am creating a collage for each day of the year to show that we can re-imagine any random day.

I begin with the front page, cutting words or phrases from headlines, captions, or ads. As I look through the pages for a second or third time, a theme will begin to unfold. I rearrange fragments of text to write the found poetry that is at the heart of my collages. Then I walk down the stairs to my underground studio. In the tradition of the *bricoleur*, I work with whatever is at hand to create my collage. I gather paints, stamps, pens, glue, thoughts, and sometimes photographs to re-imagine that day's news. The passion behind my work stems from a thought. I've read more than once. Out of all the problems in the world—war, addiction, violence, crime, intolerance, poverty, and disease—the biggest problem is a lack of imagination. If we can't envision things differently, we can't make them happen differently. So while many lament the headlines, perhaps we should take a deeper look to awaken something more real, more dear, and entirely possible lying in wait.

My artwork is entirely text-driven. A writer and a reader all my life, I've never been formally trained as an artist, which has brought a kind of fearlessness to my work. There is a freedom in doing something you've never been expected to do well. Once I write a poem, I imagine how I might illustrate it. In my new life as an artist I find myself looking for more things and looking at things more. If my found poem requires drawing a hat, I go to the bookshelf to find pictures or to my closet to find hats. Following my self-prescribed rule that the collage must be completed in one day, there's no time to even attempt perfection. Nor are there mistakes. Often, the happy accidents make the collage fresh and inviting in ways I could never plan. I choose the colors by the feeling or imagery of the words; for example, a silvery blue sky of possibilities or a mossy green field of nestled seeds. In my work you may see the tremor of the hand—a smudge, a drop of paint, a torn edge—as I seek to "re-habitate" the day while creating the collage. I get lost in the process, which becomes kind of a meditation, inner work as well as artwork you can see.

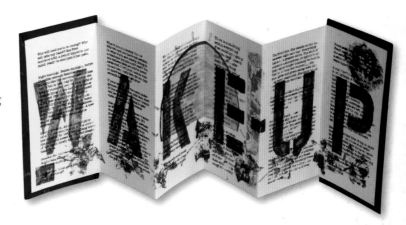

My Daily News collages have become a minefield of inspiration leading to other art projects that I will share with you in this chapter, including mixed-media posters, poetry blocks, and handmade books. At the heart of my approach is a simple philosophy: Keep creating because what happens on this colorful mix of papers might make a difference in what will appear in tomorrow's black and white news.

—Bette McIntire

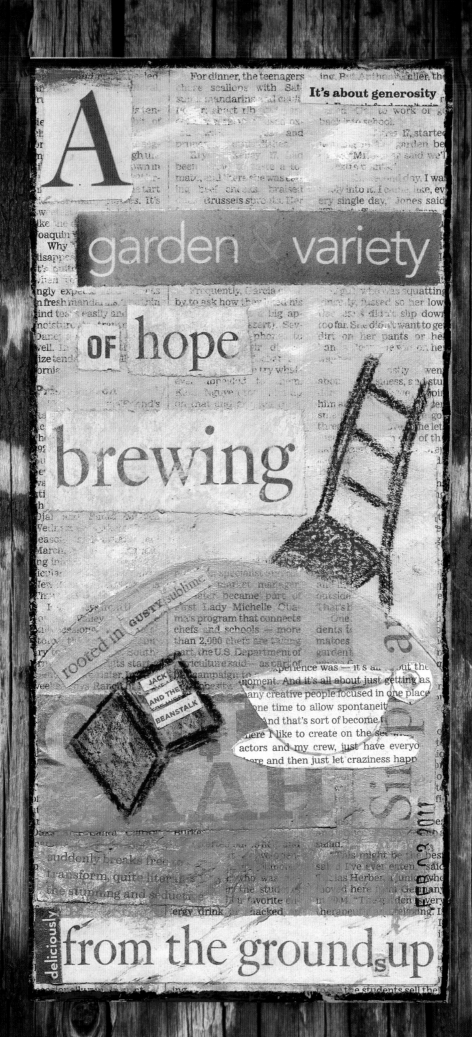

Daily News Collage

The Daily News collage begins with a "found poem" taken from one day's newspaper. It's written with fragmented text taken out of its context. Photos, newspaper images, or found papers can also be incorporated into the collage, as long as the words dictate the materials used. This project will teach you techniques that you can use to write your own found poem.

Materials

- Acid-free archival-safe paper spray
- Cardstock
- Craft brush
- Crayons (blue, red)
- Gouache paint (cerulean blue, leaf green, violet, white, yellow ochre)
- Metal ruler
- Neutral-pH adhesive
- One daily newspaper
- Pencil
- Rubber gloves
- Scissors
- Scrap paper

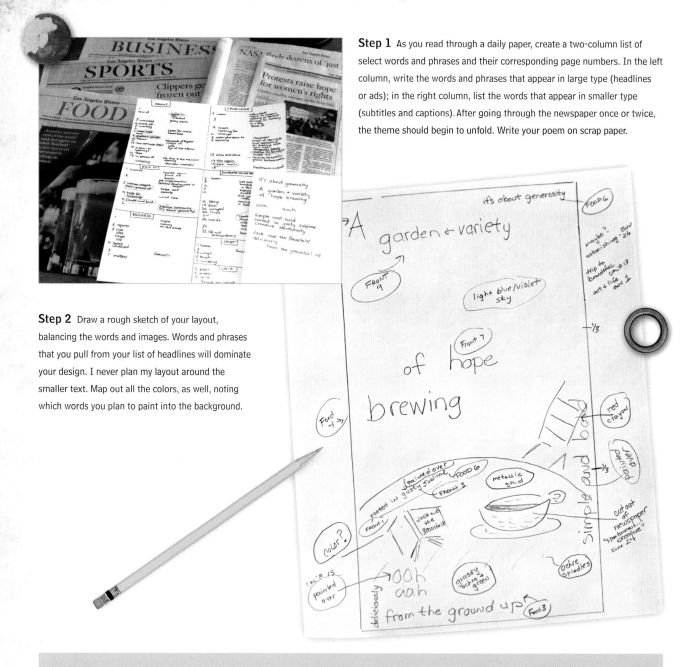

Step 1 As you read through a daily paper, create a two-column list of select words and phrases and their corresponding page numbers. In the left column, write the words and phrases that appear in large type (headlines or ads); in the right column, list the words that appear in smaller type (subtitles and captions). After going through the newspaper once or twice, the theme should begin to unfold. Write your poem on scrap paper.

Step 2 Draw a rough sketch of your layout, balancing the words and images. Words and phrases that you pull from your list of headlines will dominate your design. I never plan my layout around the smaller text. Map out all the colors, as well, noting which words you plan to paint into the background.

Composing a Poem

Rearrange the words and phrases you have selected from the newspaper so that their meanings change. Use words out of their original context to make unexpected connections with other words. For example, I took "Garden & Variety" from an ad for bedroom linens and combined it with "hope" from a front-page headline and "brewing" from an article about brewing beer. I changed the meaning by juxtaposing "brewing" with a coffee cup. It became "hope brewing . . . from the ground(s) up" (adding the "s" to interplay the idea of "ground" with coffee grounds). The title on the blue book is *Jack and the Beanstalk,* which I cut from the theater listings that day—again playing on the theme of hope rising; this time in the form of a green beanstalk. And how do you create hope? "It's about generosity," a phrase cut from a restaurant review. The size of the words, the spacing in the design, and the colors and imagery you choose will all influence the meaning of your found poem.

Step 3 Press a metal ruler down firmly on the newspaper and use it to tear out your selected words. For small text, use scissors.

Step 4 Select an article loosely related to the poem's theme to use as the collage's background.

Step 5 In a well-ventilated room, while wearing rubber gloves to protect your skin, spray both sides of your newspaper elements with acid-free archival-safe paper spray.

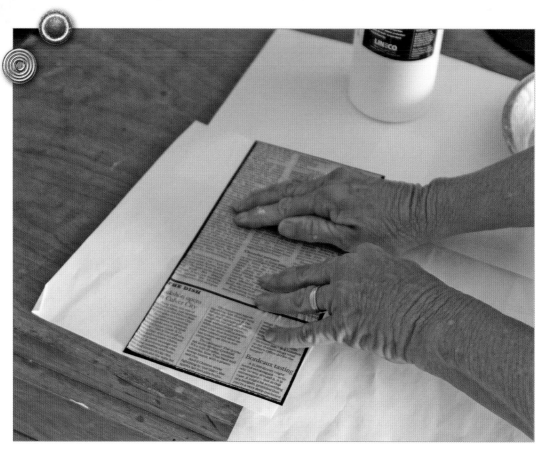

Step 6 Cut a 5- by 11-inch backing out of colored card stock. Choose a color that will make the design pop. Use a neutral-pH adhesive and a craft brush to glue the newspaper background in the center of the cardstock, smoothing it down from the middle out to the edges.

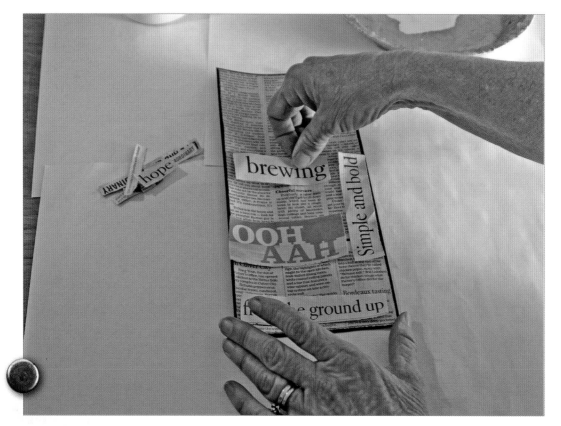

Step 7 Referring to your layout sketch, arrange the words on the background until you are pleased with the composition.

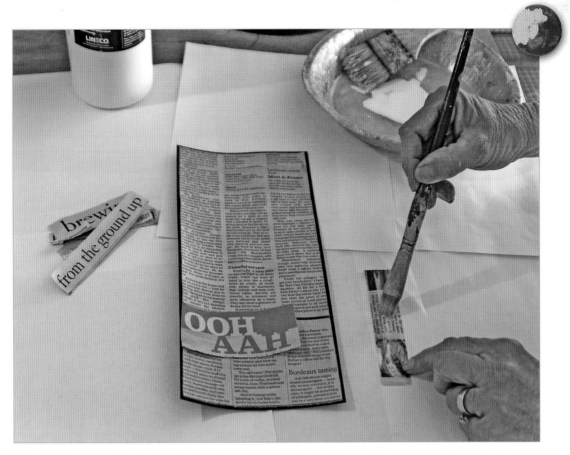

Step 8 Using a neutral-pH adhesive, glue down the words that you plan to paint over to blend into the background, and set aside the others.

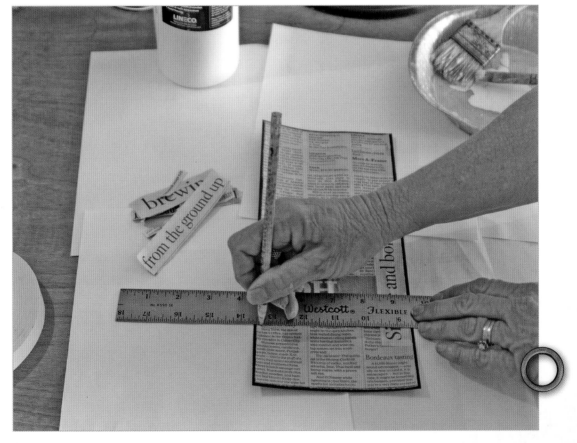

Step 9 Use a pencil to sketch in the background lines. In my sample, I drew horizon lines to denote the areas of the ground, the tabletop, and the sky. I then used a rounded template to lightly sketch in the tabletop.

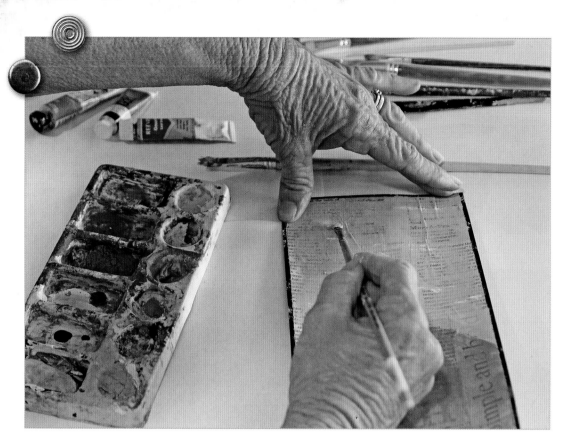

Step 10 Paint over the background with gouache. You may paint a light wash over words that are to remain legible, or leave them unpainted. With a flat, dry brush, paint the ground with a mix of leaf green and yellow ochre gouache. Paint the sky with a mix of cerulean blue, violet, and white; then paint the tabletop with metallic gold. Finally, paint ochre spindles of grass on the ground and white clouds over the sky.

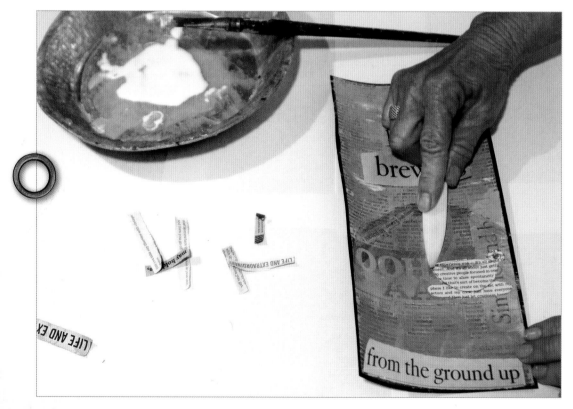

Step 11 Cut shapes out of the newspaper that support your theme; then use the adhesive to apply them to the collage. I created a coffee cup shape and penciled in the details. Attach the remaining words, and then add touches of paint that match the background colors around the torn words to blend them into the collage while leaving the words legible.

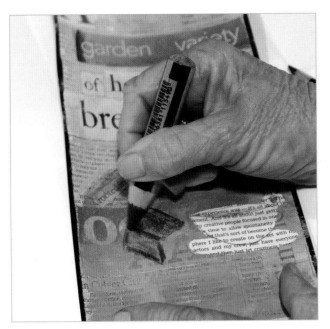

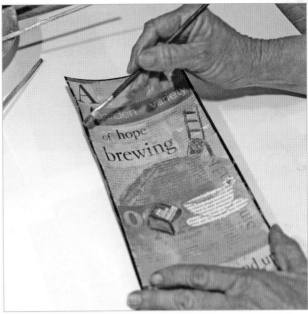

Step 12 Draw images on your collage. I used a pencil and a thick red crayon to draw a chair, and a thick blue crayon to draw the book on the table.

Step 13 Use gouache, pens, or crayons to add irregular touches of color to the border. Then use a stamp or write the date of the newspaper on the collage.

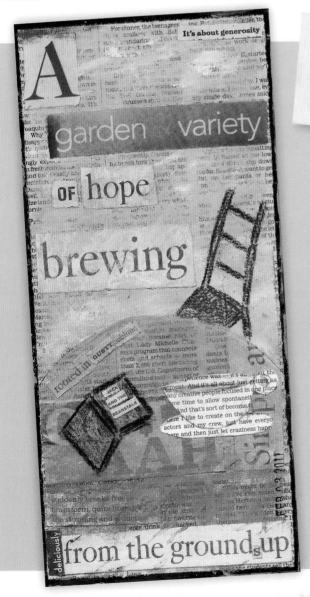

Found Poem Translation

It's about generosity

A garden & variety
of hope brewing

ooh aah

simple and bold
rooted in sublime
creative spontaneity

Jack and the Beanstalk

deliciously
from the ground(s) up

words and phrases taken from
Los Angeles Times
February 3, 2011

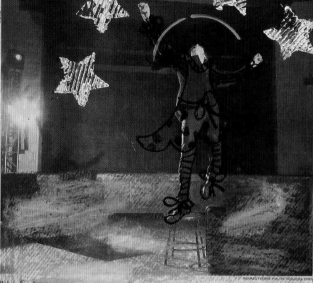

In London, Unsmiling Villainess From Italy

From First Arts Page

Donizetti work. And he had a gifted and willing cast, headed by the lustrous British soprano Claire Rutter in the title role and the rising American tenor Michael Fabiano as the impulsive young nobleman Gennaro (Lucrezia's son from an earlier marriage who was taken away from her at birth, though Gennaro does not discover this until the tragic final scene).

Mr. Figgis says he began the project with no intention of incorporating film into the staging. But he changed his mind along the way and shot four short films that present the back story of Lucrezia and the ruthless Borgia family. With these interspersed segments, filmed in a castle outside Rome with a compelling cast of Italian actors, Mr. Figgis tries to provide historical and metaphoric context for the characters in the opera.

One segment shows a sensual actress, as Lucrezia, eagerly arranging a liaison between her maid and a handsome servant. Lucrezia's malevolent brother, assuming that the servant is sleeping with Lucrezia, informs his father, the pope, and kills the young man with two accomplices and the pope's blessing. The filmed segments are sexually graphic and richly melodramatic, complete with hauntingly altered bits of orchestral music from Donizetti's score.

The problem is that the films are more involving than the live opera, which is staged conventionally, with realistic sets by Es Devlin and period costumes by Brigitte Reiffenstuel. For the mysterious scenes the stage floor

Filmed segments that are sexually graphic and richly melodramatic.

fills with smoke, and shafts of light from the wings cast the singers in shadows: all standard fare in opera productions. During ensembles Mr. Figgis favors stand-and-deliver placement of the singers and chorus.

I felt sympathy for the singers, who were dramatically dwarfed by their Italian-speaking counterparts on the big screen. Ms. Rutter has a gleaming and agile voice. She incisively dispatched the coloratura flights, which sometimes turn demonic, and was engrossing during the long stretches of dramatic recitative. Mr. Fabiano was a strong Gennaro, singing with warm sound, poignant colorings and ringing top notes.

The bass Alastair Miles was vocally stentorian and aptly censorious as Lucrezia's conniving husband, Alfonso, Duke of Ferrara. The performance was sung in an effective English translation by Paul Daniel, a former music director of the English National Opera, who conducted a stylish and well-paced account of the score here.

Elizabeth DeShong, a young mezzo-soprano with a big, bright and pleading voice, was wonderful as Orsini, a nobleman in the service of the Venetian Republic and Gennaro's best friend. Both settings the Orsini as a pants role, a female playing a male character, this made little sense to Mr. Figgis, who turned Orsini into a f-

Feet on the Furniture, and Other Playful Moves

CLOUDS

A Drama Revived by the Kindness of Strangeness

From First Arts Page

A Rocker From the Heartland, Aging Brightly but Not Discarding the Past

altering the sound.

Restless And a Bit Dreamy

"It's the unrest inside me, I think I'll go mad," sang the beautiful young woman in a whisper tinged with an otherworldly vibrato,

Swinging On a Star

Maude Maggart *in her new show "Everybody's Doin' It," at the Oak Room*

Newspaper Page Poster

This mixed-media poster is composed of a full newspaper page decorated with crayons, pastels, pencils, and stamps. The layout of columns and photos on the newspaper page offers a wonderful grid on which to plan your design. This poster, which starts with a found poem, was created from the Arts section of the paper, but other sections can offer marvelous starting points for a poster as well.

Materials

- Acid-free archival-safe paper spray
- Black crayon
- Colored pencils (various colors)
- Corrugated cardboard
- Crayons (green, deep blue, red, orange, black)
- Gold metallic pen
- Gouache (metallic silver)
- Green and Renaissance gold inks
- Leaf or other found objects
- Newspaper page
- Pastels (white, olive, pale blue, raw sienna, white, red-orange)
- Rubber gloves
- Scrap paper

Step 1 Choose words from newspaper headlines, text, and captions to create your found poem; then write the poem on a piece of paper. In this project, I added the words "clouds" and "thank you" to the poem, as the lettering will become part of the design.

Step 2 Wearing rubber gloves and working in a well-ventilated area, spray the face of the newspaper page with the acid-free archival-safe paper spray.

Step 3 Use a pencil to create a design around the layout of the headlines, columns, and photographs. Draw lines around the words and headlines that you wish to emphasize in the finished work.

Step 4 Color in the various sections of your design, leaving marked words uncolored. I used pale blue pastel for the sky, white pastel for the clouds, olive pastel and green crayon for the upper and lower ground, and raw sienna pastel for the center bottom section. I colored the upper text in the column on the right with a deep blue crayon, and used white pastel on the photograph, making the woman appear dreamy.

Step 5 Begin adding embellishments that add color to the work. In the left column, I used the bottom of a cup as a guide for imprinting a repeated sunset pattern with red and orange crayon. I broke the pattern with an imposing rectangle colored with blue crayon to highlight the words "and richly melodramatic." I then bordered the words with a thick #2 pencil to make them pop.

Step 6 Begin adding your own words with a thick black crayon. I used the fold of the newspaper as a guide for placing the letters. Then I randomly colored a few clouds into the blue sky area with white pastel.

Step 7 Continue to embellish your art with color. I used crayons, pastels, and colored pencils. I drew lines around the words of my poem to highlight them, shaded several areas in different colors, and began adding graphic and design elements. For example, I drew bursting lines with red crayon near the bottom of the page to accent the words "altering the sound."

Step 8 Next use found objects to create stamps. I mixed together green and Renaissance gold inks; then I dipped a garden leaf into the mixture. I then stamped the leaf on the poster over a photograph. Practice stamping on a piece of scrap paper before applying the stamp to your artwork.

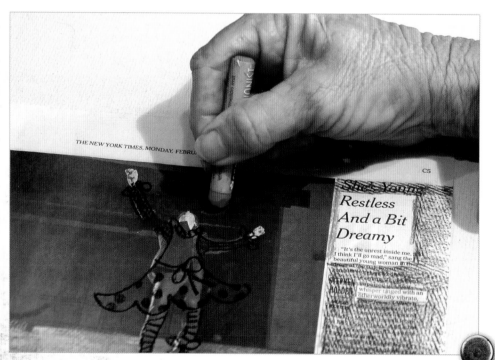

Step 9 Transform the artwork into your own. I used a black crayon to draw a skirt, tights, and boots on the figure in the photograph. I also added hair with red-orange pastel and created a halo with a gold metallic pen.

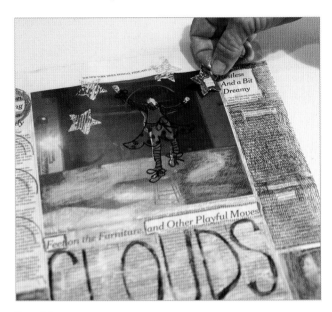

Step 10 Cut a stamp out of corrugated cardboard and brush it with paint. I cut out a star and inked it with metallic silver gouache. After testing the effect on scrap paper, I stamped four stars around the gold halo.

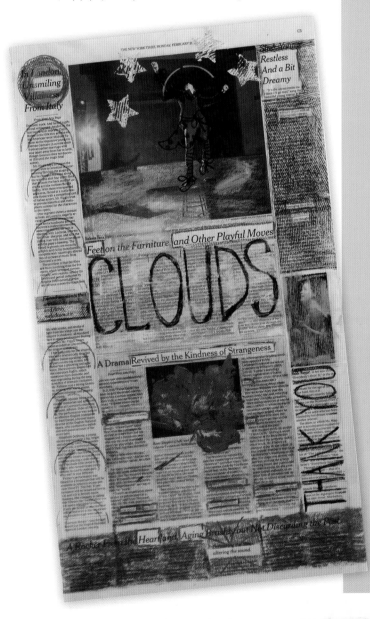

Found Poem Translation

Smiling

Feet in clouds and other playful moves
restless and a bit dreamy
"It's the unrest inside me . . .
 I think I'll go mad"
 sang the beautiful young woman

swinging on a star
you thought

and richly melodramatic
revived by the kindness of strangeness

you didn't have to sweep all that away

if you watch you find
diverse source material
looking for a different way
a variety of influences
kindly alive

the idea of the Writer making
this as it's happening . . .
we're actually making the thing
we're watching

heart aging
altering the sound

thank you
words and phrases taken from
The New York Times
February 21, 2011

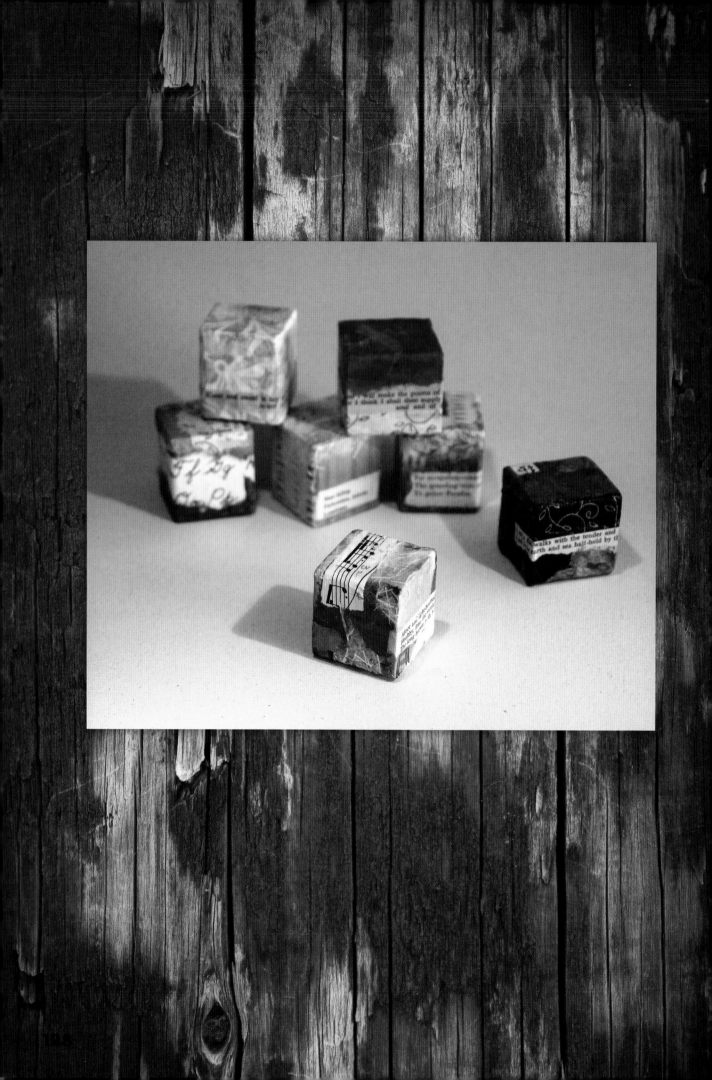

Poetry Block

A poetry block is a small wooden cube about the size of a child's alphabet block, and wrapped with papers containing one to three lines of poetry. A collection of poetry blocks can serve as an ever-changing assemblage on a coffee table, desktop, or shelf. And it's a great way to bring poetry into your home!

Materials

- 1-1/2- by 1-1/2-inch blocks of wood, lightly sanded
- Clear acrylic polyurethane
- Matte finish
- Medium grit sandpaper
- Neutral-pH adhesive
- Paper scraps of various texture and color
- Three lines of poetry from an old book

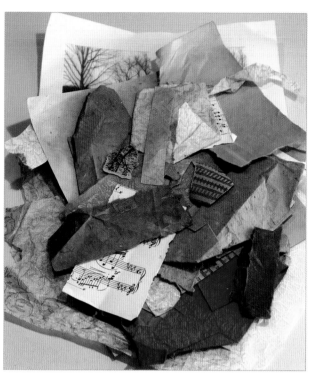

Step 1 Choose one to three lines of poetry from a used book, and tear them out. I used the opening lines to "Song of the Open Road" by Walt Whitman.

Step 2 Gather scraps of paper in colors that reflect the mood or imagery of the poem. Any pliable paper will work, including tissue paper, gift wrap, junk mail, old books, sheet music, Japanese papers, and even paper left over from old art projects.

Step 3 Plan the block's design with the poem in mind. Tear your paper scraps into random-sized pieces with irregular edges; then affix them to the block in overlapping layers with a neutral-pH adhesive. For my "open road" block, I used green strips of fibrous paper at the bottom to show the open road and tan paper to show the earth. I used light blue paper with white-tissue clouds irregularly placed for the sky, and I used bars of music to convey a free spirit.

Step 4 Glue your lines of poetry between the earth and sky.

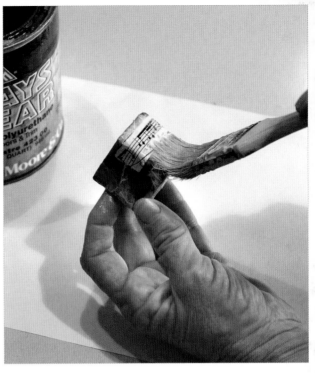

Step 5 In a well-ventilated room, spray three sides of the block with matte finish to set the colors. Set the block on its untreated side to allow the other sides to dry thoroughly; then spray the fourth side and allow it to dry.

Step 6 Brush three sides of the block with clear acrylic polyurethane. Set the block on its untreated side to dry for three hours. Repeat the process on the fourth side. For a matte block, instead of a glossy block, repeat step five.

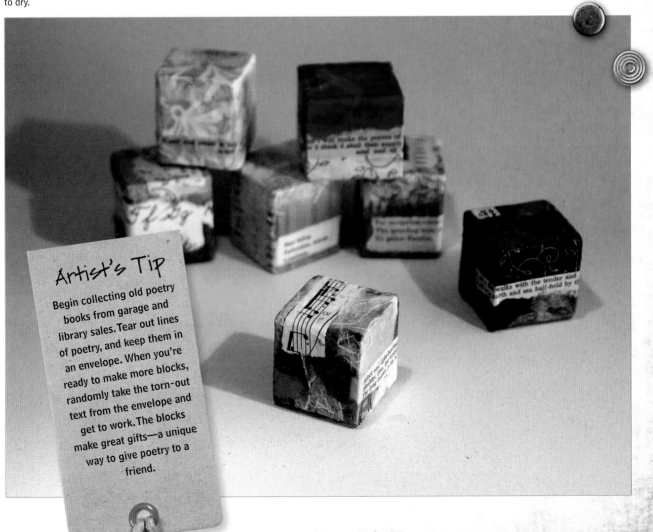

Artist's Tip

Begin collecting old poetry books from garage and library sales. Tear out lines of poetry, and keep them in an envelope. When you're ready to make more blocks, randomly take the torn-out text from the envelope and get to work. The blocks make great gifts—a unique way to give poetry to a friend.

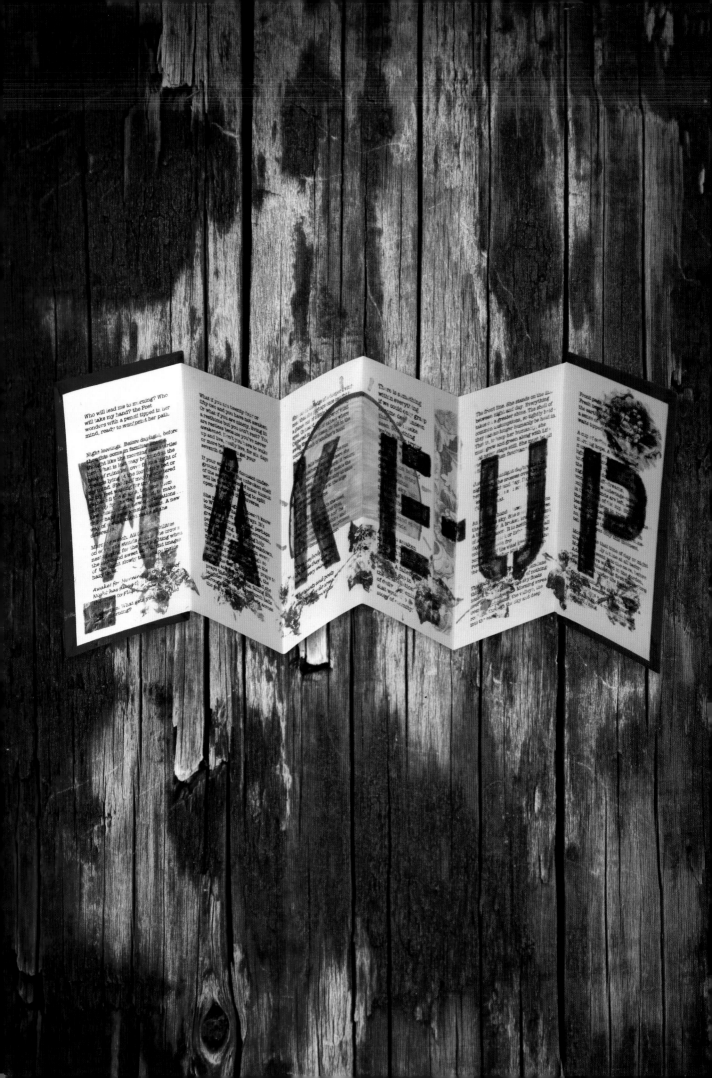

Accordion Book

Each panel in the accordion book showcases one large letter with a background of text and artwork. When unfolded, each letter is revealed as part of a word or phrase. My word is "WAKE-UP," which is the theme of the book's artwork. Names of people and places also work well as themes in an accordion book.

Materials

- 4-inch letter stencils
- 120lb watercolor paper
- Acrylic paint (metallic gold)
- Artist tape
- Found, textured objects for stamping
- Glue
- Gold and green printer's ink
- Gouache paint (cerulean blue)
- Heavy-weight decorative papers
- Japanese paper
- Laser printer
- Metallic gold pen
- Metallic printing ink
- Museum board
- Neutral-pH adhesive
- Paints and pens (various colors)
- Paint/varnish remover or acetone
- Spoon
- Thin decorative paper (for book cover)

Image Transfers

Image transfers are a great way to print text or add pictures to your collages and books. Practice and experiment with different papers and images to get the effect you want before transferring them onto the pages of your accordion book.

Step 1 Scan text, a photo, or any found decorative paper onto your computer.

Step 2 Using a computer software program, create a mirror image of your scanned image (I use Pixelmator®), or have it created at a print shop.

Step 3 Print out several copies on a laser printer.

Step 4 Cut the images (or text) into pieces that will fit nicely on the pages of your accordion book. For a ragged edge, tear the images.

Step 5 Position the text or images face down on the panels of the accordion book with artist tape.

Step 6 In a well-ventilated room, brush paint/varnish remover or acetone onto the backs of the images and burnish them to the accordion book with a spoon. (See "Artist's Tip" on opposite page.) Peel back slowly, making sure the image has transferred. Some broken type is okay; the text is for the background and meant to be legible only in fragments. The irregularity of the text or images is essential to the beautiful look created with this process.

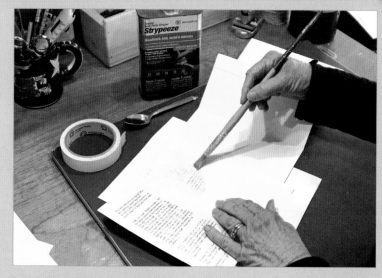

Apply paint/varnish remover or acetone.

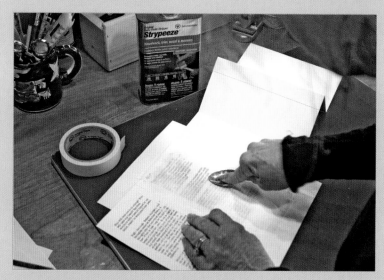

Burnish the transfer with a spoon.

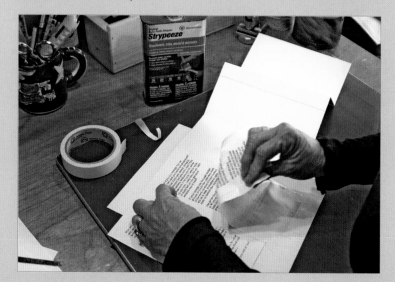

Peel off the transfer paper.

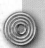

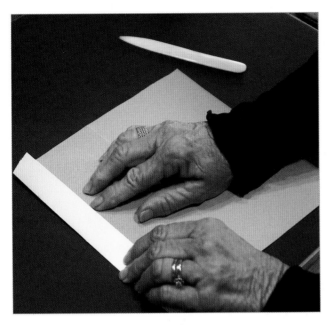

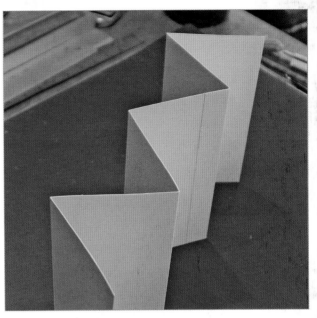

Step 1 The accordion book requires 120lb watercolor paper with a smooth matte finish suitable for printing. Find or create a "duplex" paper—white on one side and colored on the other. Cut the paper in one 16- by 8-1/2-inch piece and one 9- by 8-1/2-inch piece. Measure and score 4-inch panels on each piece of paper, adding a 1-inch fold on the 9-inch piece for an overlapping tab.

Step 2 Glue the 1-inch tab so that it attaches the two strips of paper to each other. Next fold the paper in half; then fold it like an accordion into six 4-inch panels. Trim the top and bottom to make the book 8 inches tall.

Artist's Tip

Experiment with different chemical fluids to see which works best for transferring text and images for your particular project. Strypeeze® has worked for me, but you may find success using other types.

Step 3 Choose text that relates to your word. My text is a vignette I wrote called "Morning Mind." Format your text on a computer or cut it from its source so that it fits each panel of your book. Make a mirror-image laser print of your text to transfer onto the panels of your book. (See "Image Transfers," on opposite page.) Decorate the 1-inch tab at the end of the fourth panel by transferring a patterned-paper design onto it, or by using paints, pens, and a design template.

Step 4 Use a metallic gold pen and metallic gold acrylic paint to make a rising sun on the third and fourth panels; then add sun rays. I dipped the top line of an exclamation point stamp into metallic gold paint to create the rays.

Step 5 Using 4-inch stencils, paint one letter on each panel with the gouache to create your chosen word or phrase. Alternate between applying smooth brushstrokes and dabbing on paint with a dry brush to create a weathered appearance.

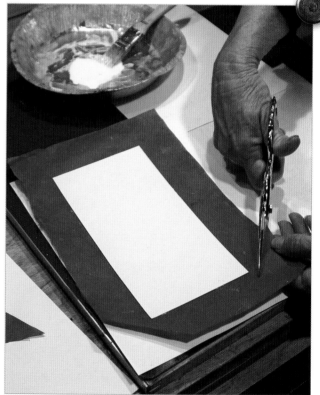

Step 6 Gather images from a collection of your own photographs or found papers; then use the transfer method to illustrate your book. Follow the steps for creating stamps with found objects from "Newspaper Page Poster," on page 123. Then embellish your book with stamps as desired.

Step 7 Cut 8-1/2-by 4-1/4-inch front and back book covers out of four-ply museum board. Place each museum board cover in the center of your thin decorative paper, cut to 12-1/2 by 8-1/2 inches. I used a delicate handmade paper with leaf impressions for the cover material. Cut off the corners of the cover paper diagonally so that the center of the cut meets the corner of the museum board.

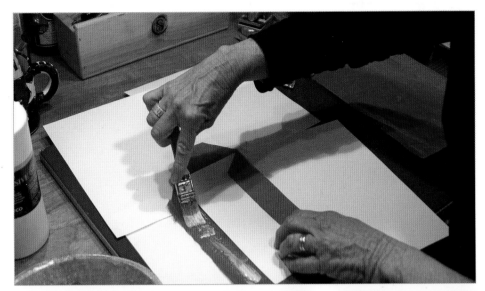

Step 8 Apply a neutral-pH adhesive to the exposed parts of the cover paper, and then fold them up and press them onto the museum board.

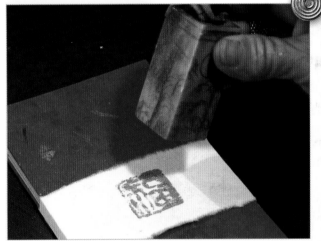

Step 9 Cut a 10-inch strip of Japanese paper, which will be turned into a moveable band that will keep the book closed. Overlap and glue the ends together to create a band that's slightly longer than 4-1/4 inches on each side so it will slide over the closed book.

Step 10 Next, find a textured object to create a stamp to embellish the center of the band. I used a Chinese character stamp dipped in metallic printing ink.

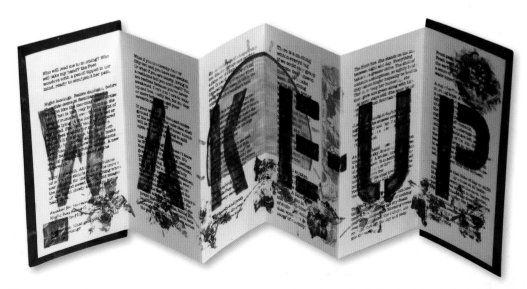

Step 11 Cut two 1- by 1/2-inch "legs" out of the same 120lb paper you used to make your book. Glue the legs onto the backside of the bottom left portion of the third panel and the bottom right portion of the fourth panel so that the panels stand level with the covers when you unfold it.

Experiments in Texture

with Patricia Swartout

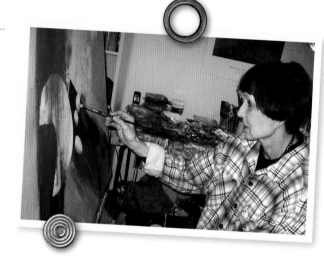

Patricia Swartout first became interested in art when she was a child growing up in Southern California. Upon attending college as a young woman, however, she studied merchandising and steered clear of art classes—she was not ready to be influenced by modern art. Instead, she painted realism, studying the Old Masters' techniques. Later she moved on to pointillism, a technique in painting in which objects are rendered as a series of small dots.

Patricia currently resides in Spokane, Washington, where she creates art in her home studio. She has studied at the Spokane Art School and the Corbin Center, and she attended Spokane Falls Community College, where she majored in both graphic design and fine arts. It was here that she began her journey into abstract expressionism. Patricia has moved on from creating pieces with identifiable objects to those that combine organic and geometric shapes, as she prefers the contrast of varied shapes in conjunction with the contrast of blended and sharp edges. This chapter features artwork that Patricia created when she was experimenting with finding new ways to incorporate texture into her abstract acrylic paintings.

Inside the Artist's Studio

The first decisions I make when approaching a blank canvas are what colors to incorporate and whether I want to use geometric shapes, organic shapes, or a combination of both. If I prefer geometric shapes, I use a photo of buildings or other manmade structures as a reference. If I want organic shapes, I find a photo of natural elements, such as trees, flowers, or stones from which to draw inspiration. For color, I generally prefer a limited palette of earth tones.

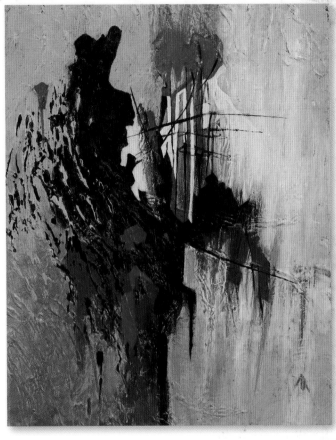

Arrangement

Photoshop® takes the place of traditional thumbnails in my artistic process. It allows me to crop and rotate photographs; change shapes within an image; increase the brightness and contrast; and change, intensify, or fade colors. I begin each painting by scanning my chosen photo, or combination of photos, into Photoshop®. Then I alter the shapes, values, and hues, and I add and subtract elements within the image. I often render darker colors toward the bottom to give the reference a base. I also use this process to establish a focal point, which is usually the brightest or lightest colors or the shapes with the sharpest edges. Outside the focal point, I use shapes that are hazy or blended. I play with the image until I have something I admire. When I'm finished, I print it and evaluate it to ensure that I'm satisfied with the composition. The printed image becomes my reference for the project I'm about to start. Sometimes I create a black-and-white printout as well so that I can see the values clearly.

The original painting beneath *Arrangement* had texture that I created by spreading plain modeling paste on the canvas with a palette knife.

I first became interested in texture after I reused an old canvas on which I had created a painting that I no longer cared for. I found that the texture from the built-up paint allowed me to create a stipple, or broken color, effect when I brushed fresh paint on top of it. I then began to look for objects to place on the canvas to create this effect when I did not have a used canvas to work with. The paintings featured in this chapter were created using some of the unconventional items that I have used to create texture in my work.

—Patricia Swartout

Wood Shavings

I used wood shavings for texture in both of the paintings on this page. The wood shavings in *Geometric Flower* (right) indicate the center of the flower. In *Ruins* (below) the shavings demonstrate the texture of the blocks that form the pillars.

For *Geometric Flower*, I used a photo of a flower among rocks because I admired the contrast between the soft and hard edges. For *Ruins*, I chose a photo that depicted imposing pillars and a crumbling foundation—all that's left from a once-great structure. It gave me a feeling of time passing.

I used charcoal to denote the center of the flower and the petals in *Geometric Flower*, as well as the position of the pillars in *Ruins* with charcoal. Next I mixed acrylic modeling paste in a bowl with water and added the desired amount of wood shavings. I applied the mixture to the canvas with a palette knife. The flower petals were covered with a thick application of undiluted modeling paste. Before it dried, I pulled a metal hair pick through it to create lines within the petals.

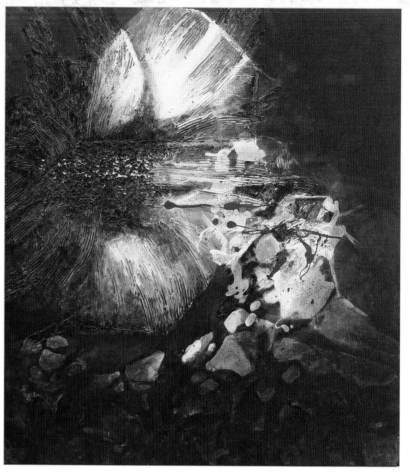

Geometric Flower

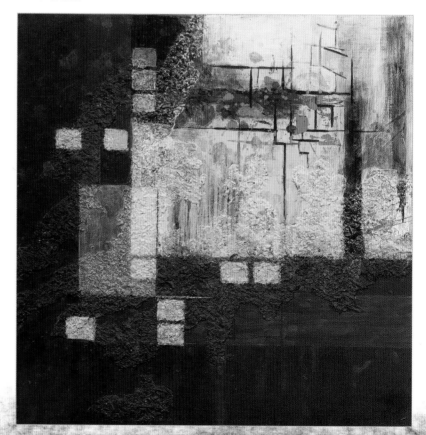

Ruins

Ground Nutshells

For *Untitled*, I spread acrylic modeling paste onto the canvas in a swirl pattern. Before it dried, I laid a piece of string on it to emphasize the spiral. Next I mixed modeling paste with a small amount of water in a bowl; then I mixed in ground nutshells. I applied this mixture to the canvas with a palette knife.

After the paste dried, I ran my hand over the texture to remove loose particles. I've never had additional texture material come off after this stage. Next I applied a solid background color over the entire canvas. Then I simply experimented with adding and subtracting colors, spooning on the paint to create interesting shapes and to give the pieces a flowing effect.

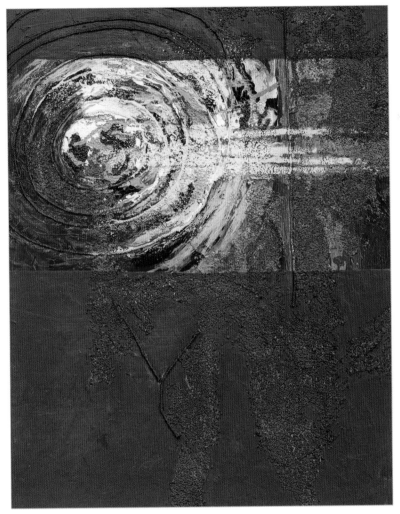

Untitled

Aquarium Gravel

Vista was imagined from a photo depicting a cloudy sky, rolling hills, and a long, stone wall in Ireland. *Landscape* was inspired by a photo of trees and a block arch. After mixing the gravel with acrylic modeling paste, I spread it on the canvas with a palette knife in areas initially indicated with charcoal drawings. After the texture dried, I painted the canvases with a solid color of acrylic paint. I then used a paper towel to wipe paint over the gravel to achieve the pattern of rocks and tree branches. To keep some of the areas of my paintings loose and flowing, I thinned the paint and spooned it on.

Vista

Landscape

Ceramic Tiles

The inspirational photographs for the paintings on this page appealed to me because they depicted a contrast between trees and manmade buildings. The Theatre du Chatelet in Paris inspired *Castle*. The apartment building that inspired *French Apartment Building* was where the 1958 classic "Gigi" was filmed.

I mapped out the placement of my elements with charcoal before I applied texture. I felt that tiles would echo the emotion of the geometric building shapes, so I attached tiles of various sizes to the canvas. I mixed acrylic modeling paste in a bowl with a bit water to thin it; then I spread a thick layer of paste onto the canvas in areas where the tiles were to be placed, expanding the paste outward with the palette knife to create more texture. After attaching the tiles, I laid the canvas flat on the floor until the paste dried.

After painting the entire canvas with solid color, I emphasized the tiles by painting them with colors that stood out from the background.

French Apartment Building

Castle

Closing Words

Now that you have mastered an array of exciting mixed-media techniques, from altering photos and transferring images to creating your own stamps and embossing foil, it's up to you to decide how you will incorporate them in your art. In time you will discover your own unique approaches to mixed media. You may even invent a few of your own tricks for creating texture and working with found objects—the possibilities are endless. Enjoy the journey!